D1422476

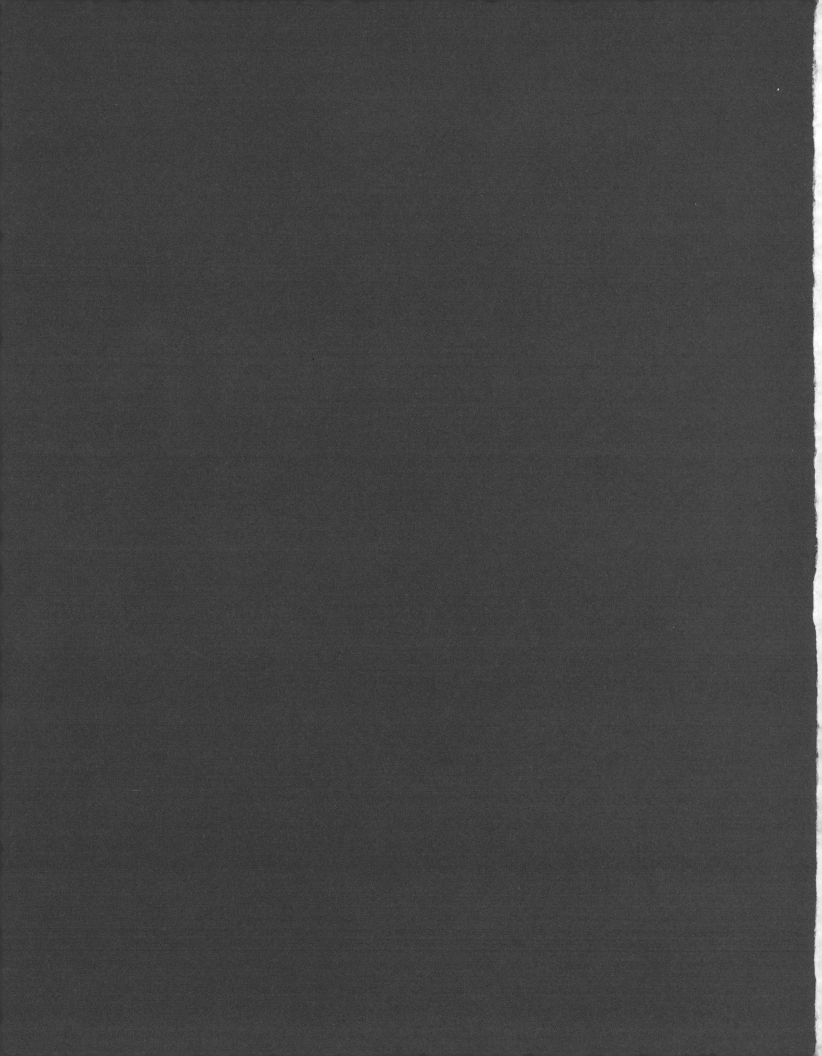

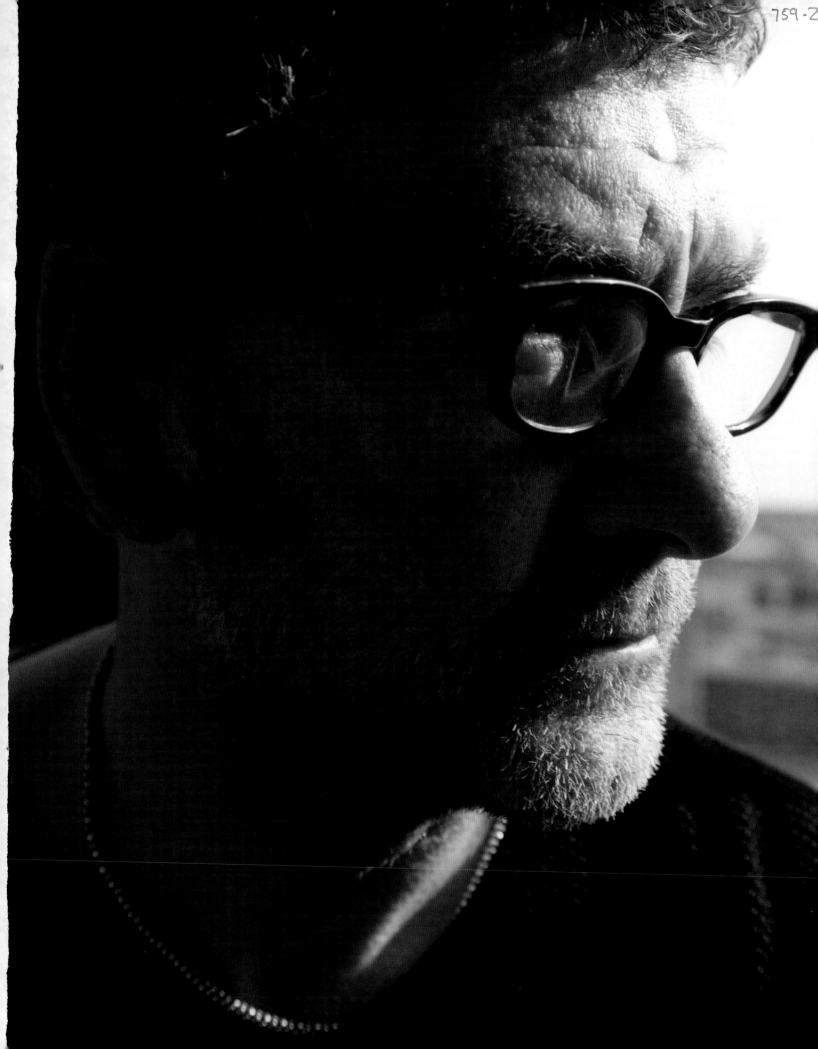

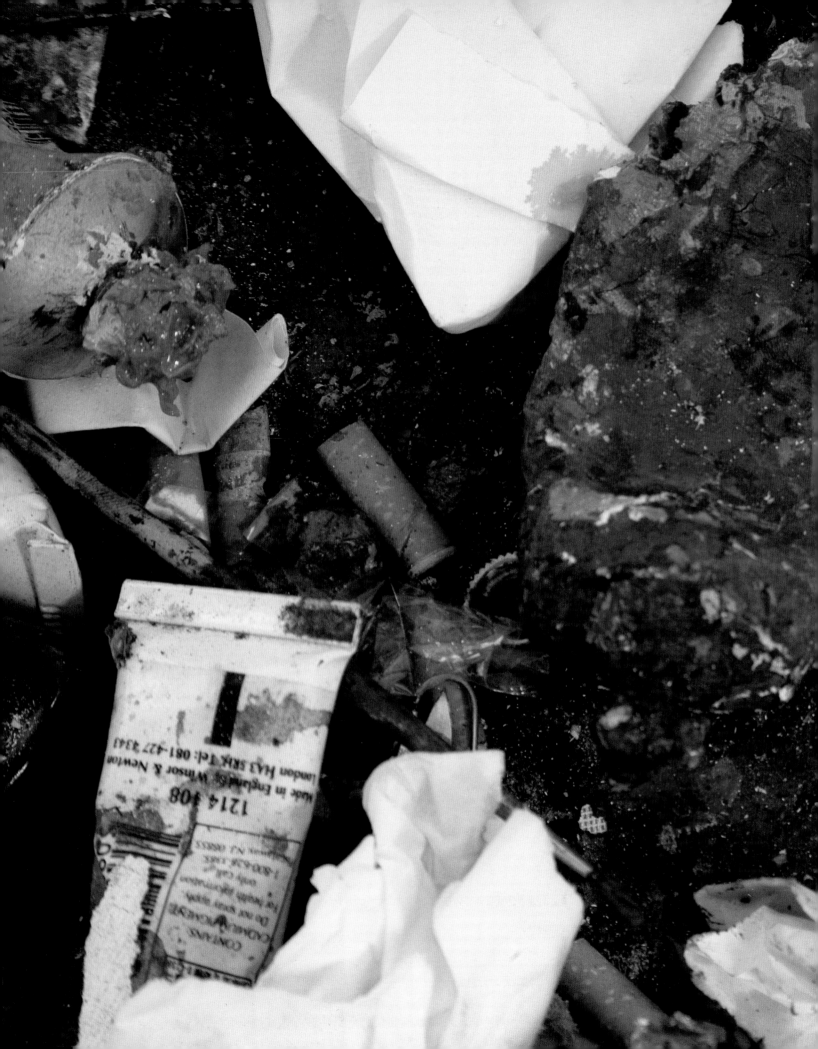

JACK VETTRIANO STUDIO LIFE

TEXT BY TOM RAWSTORNE
PHOTOGRAPHY BY JILLIAN EDELSTEIN

PAVILION

Previous pages:
The tools of the trade:
Jack's palette.

First published in the United Kingdom in 2008 by
Pavilion Books
10 Southcombe Street,
London, W14 0RA

An imprint of Anova Books Company Ltd

Commissioning Editor: Kate Oldfield
Editor: Kate Burkhalter
Art Direction: Emily Preece-Morrison
Author: Tom Rawstorne
Designer: Bernard Higton
Indexer: Vanessa Bird

ISBN 978-1-862057-43-2 1862057435

A CIP catalogue record for this book is available
from the British Library.

10 9 8 7 6 5 4 3 2 1

Reproduction by Mission Productions Ltd, Hong Kong
Printed and bound by SNP Leefung Printers Ltd, China

www.anovabooks.com

CONTENTS

Foreword by Ian Rankin
Jack Vettriano: Secret Desires 6

Part One
In the Studio 12

Part Two
A Sense of Place 74

Part Three
Cultural Influences 124

Exhibitions 154
Index 156
Index of Paintings 158
Acknowledgements/Picture Credits 159

FOREWORD BY IAN RANKIN

JACK VETTRIANO: SECRET DESIRES

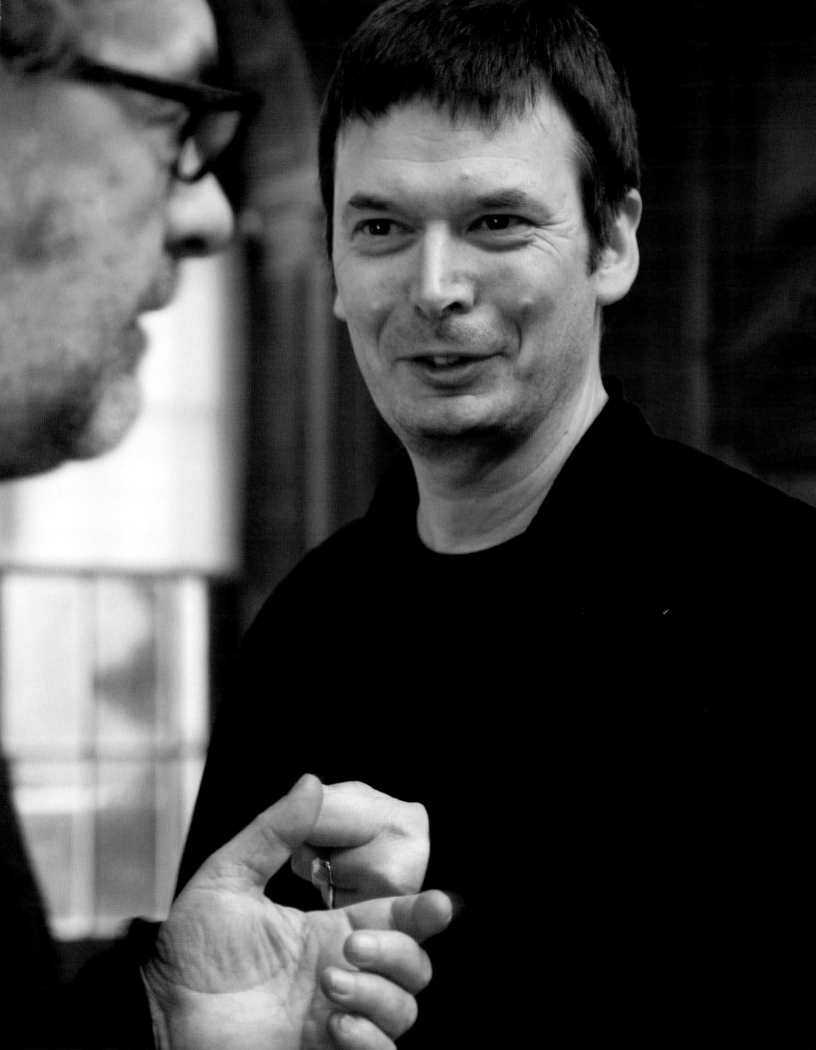

One of my favourite films is *La Belle Noiseuse*. It concerns the life of a French artist, and for long stretches of the film all we do is watch the hero sketch, draw and paint his subject (the ravishing Emmanuelle Beart). Although the artist himself is played by actor Michel Piccoli, whenever we see him at work the close-ups show the hands of a real artist, Bernard Dufour. The fascination for me lies in the depiction of this very personal and private act – the creation, from raw materials, of a genuine work of art. Painters (like writers) normally don't work with a crowd watching. Writers, of course, don't even have a model in the room – we are solitary creatures – and I've always been intrigued by the methods creative artists use, and the ways in which they conjure magic from those methods.

Jack Vettriano, too, prefers to work alone. He will take photographs of his models and then oftentimes work from those, so that there are no distractions. I was living in France when I first heard about Jack. It interested me that we came from the same area of Scotland and shared a similar working-class background. Neither of us had enjoyed formal training in our chosen fields.

On a trip back to Edinburgh, I caught one of his shows. The paintings were being displayed in a Georgian town house and I loved them. They were erotic, mysterious and seemed to me to be telling stories about their participants. Even now, when I think about the titles of Jack's paintings – *The Man in the Mirror, Cold Cold Hearts, Heaven or Hell* – they could just as easily be story titles. When I look at a Vettriano painting, I see more than brush strokes on canvas or a moment captured; I see a narrative. Who are these people? How do they relate to one another? What has just been happening and what is about to happen? It was a brilliant idea to host that show in an actual house, because it made me wonder about the private lives of all those straight-laced New Town residents. Just what secret desires were they keeping close to their chests?

I met Jack a year or two later at the Edinburgh Festival. On both occasions he was alone, an observer of the festivities around him. Later on, I contacted him and asked if one of his paintings could play a role in my next novel. He agreed, and by strange coincidence we next met on an aeroplane, just after publication. I had a copy of the book with me and was able to give it to him. It

View over the Firth
of Forth from Jack's
Kirkcaldy apartment.

to a room in his house. It was filled with samples of posters, greetings cards, calendars, jewellery-boxes and the like, all of them featuring his best-known works. In another room was displayed an academic gown, evidence of one of his honorary doctorates. He's also been the subject of a *South Bank Show* programme and had a street named after him. Quite an achievement, all in all, for a Fife school-leaver.

Whether Jack has ever quite left Fife, however, is a moot point. He keeps a large apartment in Kirkcaldy, carved out of what used to be a linoleum company's headquarters. It sits above the town and has spectacular views over the frigate-grey Firth of Forth. I grew up five miles away in the mining town of Cardenden and would travel to Kirkcaldy on Saturdays on shopping trips with my mum, and later, as a teenager, to prowl the esplanade and bluff my way into adult movies at one of the picture houses. My first poems, stories, and novels were attempts at mythologizing this backdrop, and I sense something similar in Jack's work. The elegance, eroticism and overt romanticism in his paintings depict something missing from our shared upbringings. There is a

was called *Resurrection Men*, which, now I come to think of it, could easily be a title of one of his paintings. Although we don't see one another often, we stay in touch. When a Scottish indie band called St Jude's Infirmary decided to re-create one of Jack's paintings for the video of their song 'Goodbye, Jack Vettriano', they invited both Jack and me to the shoot. Whether the blustery beach at Portobello is quite what Jack had in mind when he painted *The Singing Butler* remains to be seen, but the event itself struck me as perfect synergy. Rock music is a populist form, as is the crime novel, and Jack has often been called 'the people's painter', one of the most popular artists of his (or any) generation. He once took me

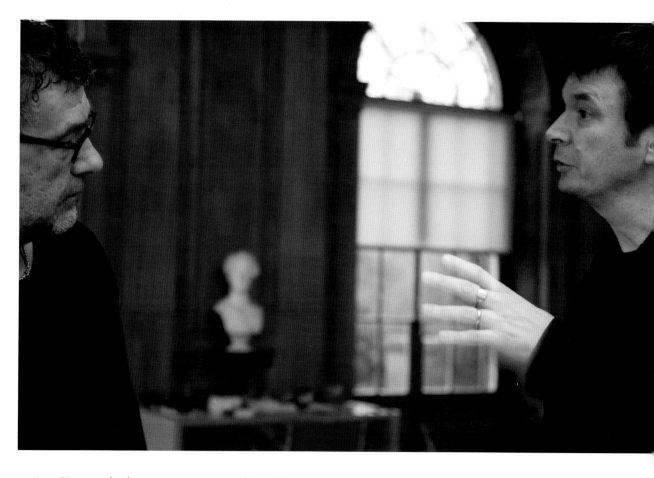

'Maybe success itself
bewilders us, or maybe
its just that we're two
boys from Fife'.
Jack and Ian chat.

saying, 'You need a long spoon to sup with a Fifer.' It means we tend to be close-knit, indeed almost tribal. We're also reticent, and slow to show our feelings. Outward shows of affection are rare; passion is something we keep locked inside us, and not for public display.

Those secret desires again.

The same secrets are unlocked by our greatest artists, from playwrights to painters, but often they are unlocked without the majority of us having any sense of the working process. This book changes all that. It shows the artist at work and play, gives an idea of his everyday environment and the dreamscapes that inform his work. We can never hope really to know what goes on inside

any creative artist's head, but the camera provides a multitude of clues to the complex character of Jack Vettriano. Here's the man I know: serious yet playful; warm-hearted yet mysterious; open-minded but never forgetting his roots. The last time I saw Jack, he drove me to Kirkcaldy railway station. We talked about the town, about family ties, about music. Everything, in fact, except our actual craft. Maybe success itself bewilders us, or maybe it's just that we're two boys from Fife, taught by our parents and our culture not to be show-offs. But Fife and Scotland can be proud of Jack Vettriano, and now, with the help of this book, you can get to know him a whole lot better, too.

Ian Rankin, 2008

IN THE STUDIO

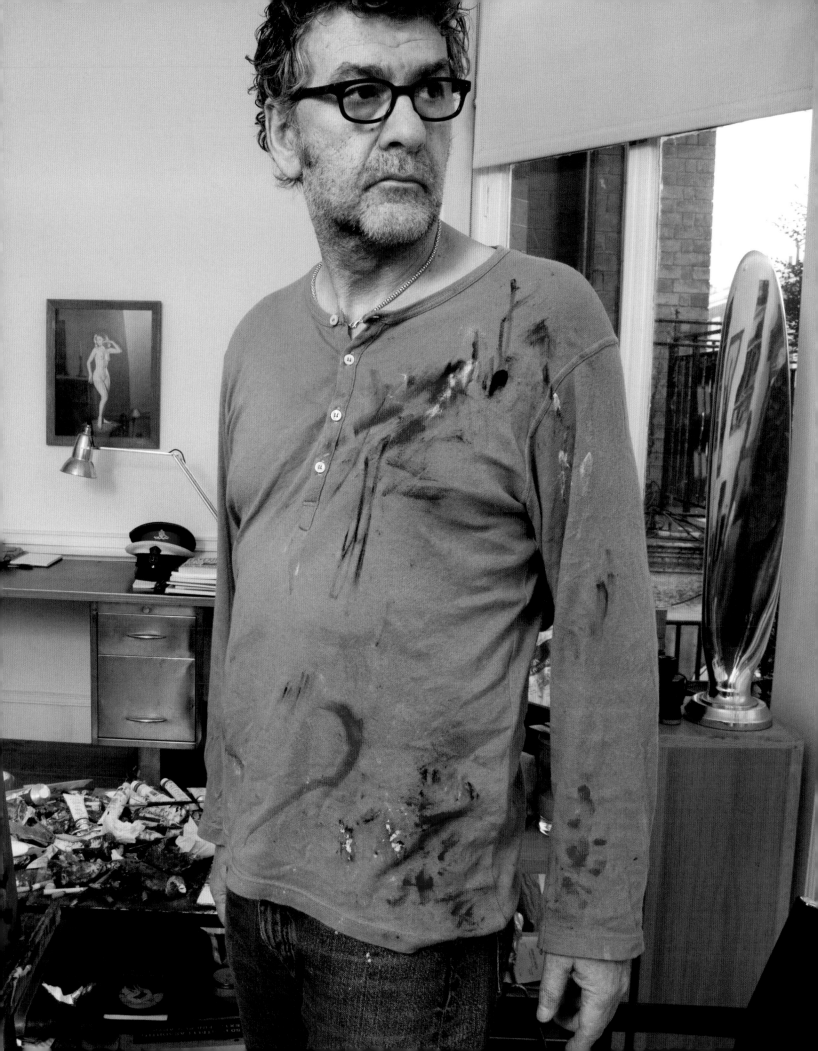

A tastefully furnished London flat a stone's throw from Harrods and a man and a woman sit opposite one another, their knees so close they almost touch.

He offers a cigarette and the brunette, her back arched and her hair tied up, reaches forward. She's wearing a little black dress and killer heels and her nails and lips are painted pillar-box red, and as she accepts a light her eyes never part from his.

What happens next is for the onlooker to decide – to imagine – for, with the click-clack of a camera shutter, the tension evaporates and the curtain falls on another moment in a day in the life of the artist Jack Vettriano.

He gets up from his armchair and, cigarette still in hand, thanks the model for her time before hurrying off to check the digital images stored on the back of the camera.

He's working towards a major new show and the routines involved in creating the new paintings are well under way.

Work is split between studios in London, Fife and the south of France, but whatever the location the day unfolds much the same. Models (generally acquaintances, sometimes lovers, always brunettes)

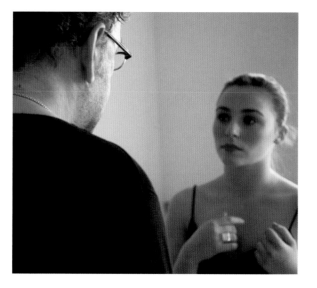

are choreographed into position by Vettriano who, like a film director, manipulates them into place and pose. Profiles are set, clothing seductively tweaked, and the props of his trade distributed and applied: lingerie, lipsticks and Louboutin high heels.

In this way, the ideas that he has been mulling over for weeks and months are transferred into three dimensions and captured on camera. Next the brushes come out, the palette is primed and a small study executed before work begins on the final canvas.

Previous pages Jack in his London studio.

Left Discussing poses with a model.

Right Caught on camera: Jack has always worked from photographs rather than life. 'I have tried to paint with a live model… it was an absolute nightmare, because I didn't have the confidence'.

Following pages Setting the scene for the painting 'Home Visit'.

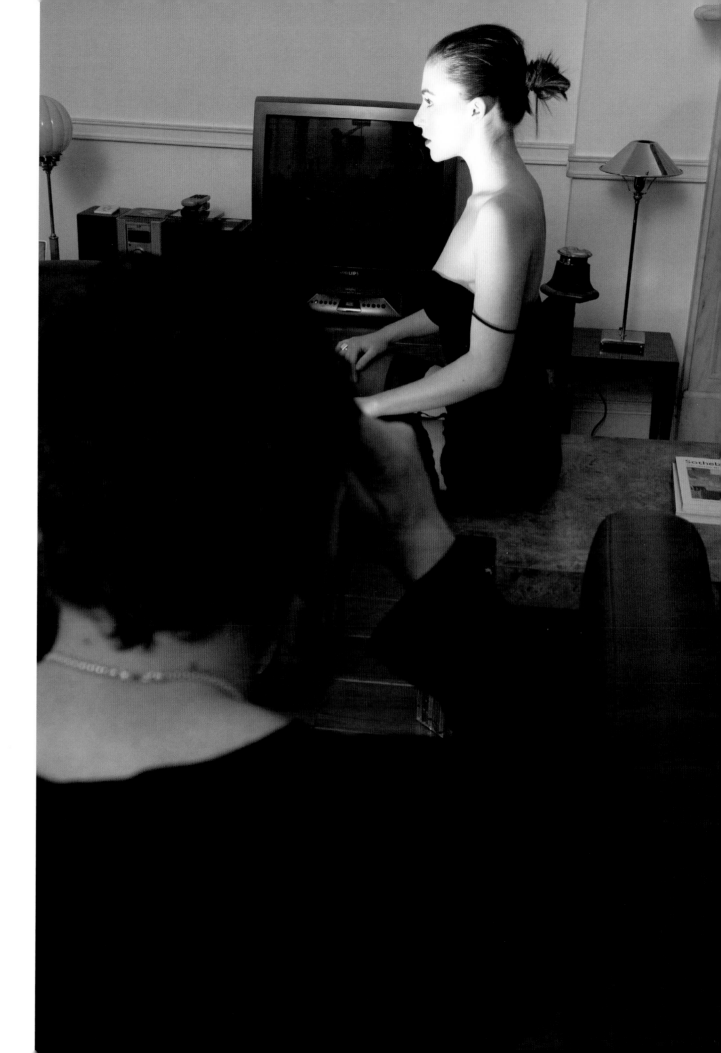

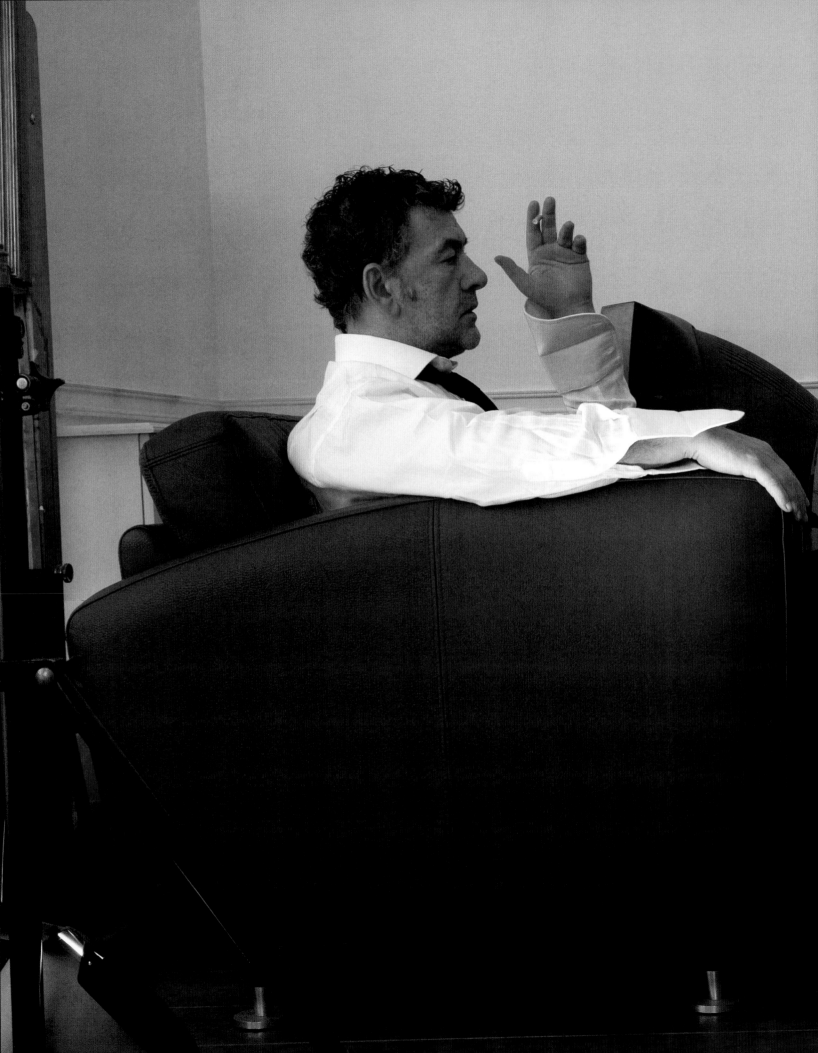

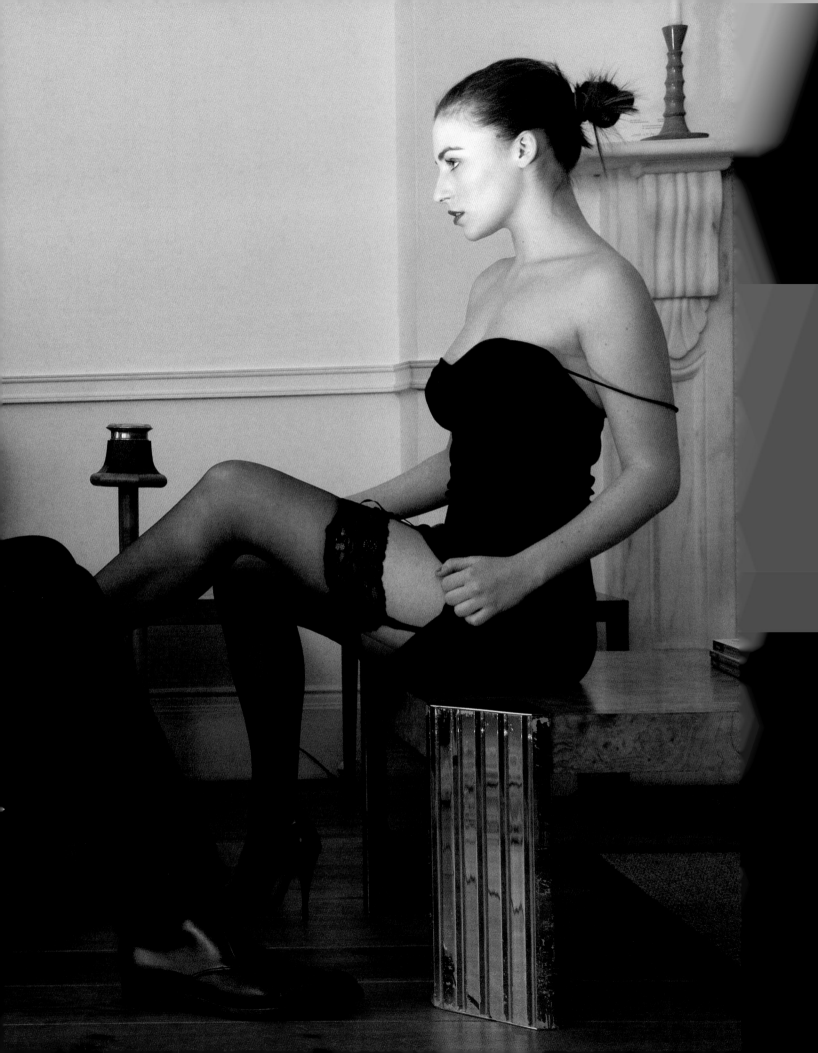

In the early days, the ideas came so thick and fast Vettriano barely had time to sleep. Bed would be a cushion thrown on to the studio floor and sustenance would comprise of cigarettes and coffee.

Today, at 55 years old, Vettriano is more conscious of preserving his energy, more conscious of the strain involved in producing work of a consistently high quality. So while he'll be up at 6 a.m. every day, there will be the odd day off, the odd day lying on the beach that stretches in front of his Art Deco flat on the Cote D'Azur. But, make no mistake, there's absolutely no chance of him packing up his easel for good.

'A man has to work, to do something, or else you will become mentally unwell,' he says. 'I love it in the south of France, lying on the beach, but after a day or two of that I start to feel a bit fraudulent, get a bit nervous. Maybe that's just the hard-working Scottish thing but it keeps me going. It's not about the money. It's about whether I'm still doing it, whether I've still got it'.

A portrait of the artist Jack Vettriano at the age of 55.

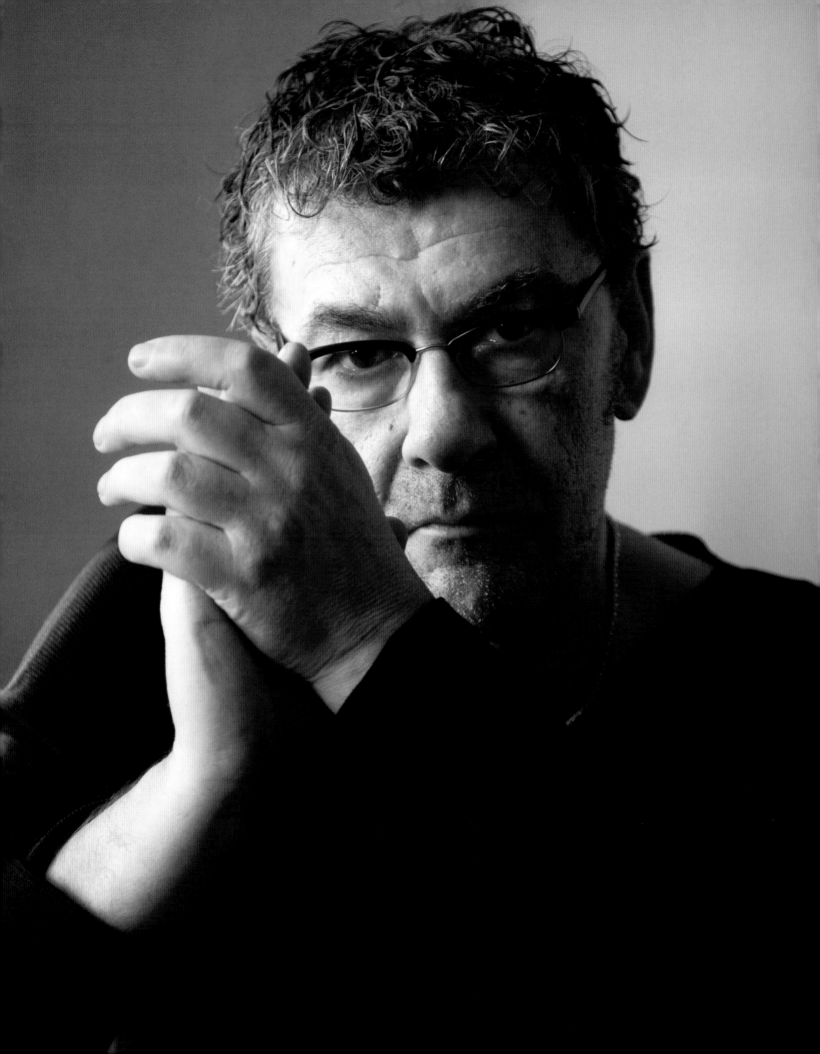

Like everyone, Vettriano is a product of his upbringing, but he feels it more than most. While the content of his work has been influenced both by his early years in the coal towns and villages of Methilhill, Leven and Kirkcaldy in Fife and, more recently, by the French Riviera, it is his extraordinary metamorphosis from miner's son to Scotland's most famous painter that has been most difficult for him. His emergence as one of the nation's best-known artists has undoubtedly transformed his life, but for a self-confessed melancholic individual the changes have not been without pain.

A naturally shy man, he has struggled to deal with life in the spotlight while the fact that he is a self-taught artist has made him particularly vulnerable to the slights of an art establishment whose refusal to accept him as one of their own persists to this day.

For years, this has pained him, worried him, made him doubt himself, and it is only recently that he has come to realise that he has nothing to hide and certainly nothing to feel ashamed of.

'I am an outsider in so far as I do not have one connection in the art world. I taught myself to paint in a back room and maybe some critics think that is a bad pedigree. But so be it. The trouble is I think their feathers are very ruffled because, regardless of what they say, the public love what I do.'

Until now, Vettriano has shied away from discussing the mechanics of how he paints, fearful he might provide ammunition for his critics. That criticism reached a peak in the autumn of 2005, when the press gleefully reported that elements of his painting *The Singing Butler* were 'copied' from an art manual. The fact that the previous year the work had been sold at auction for £744,800 (so setting a world record for a Scottish painting) only added to the hysteria.

Vettriano's natural instinct was to run from the controversy, but it soon dawned on him that he had nothing to run from. 'I have never made any claims about myself and I never will. What I do is not cutting edge, it is not pushing back any boundaries. It pleases me and fortunately it also pleases other people. I do not apologise for *The Singing Butler*, far from it. I think to have been able to do that, to have been able to create an

The detritus of a working day: detail of Jack's palette.

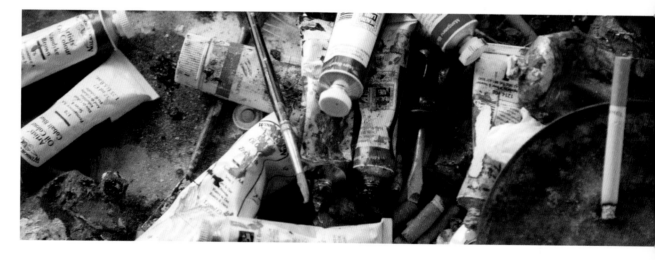

iconic image from a £17 manual deserves a wee bit more than scorn.'

So it is that, today, Vettriano no longer feels he must make excuses, must justify his art. Indeed, that he paints the way he does is the clearest reflection of who he is, of where he came from – of the remarkable journey he has travelled.

'The artist tries to get his idea down on canvas in any way he can, in any way possible and that is really what it is all about. When I have an idea, I use everything at my disposal to get it down accurately.'

To understand best the way in which Vettriano works in the studio today, it pays first to briefly turn the clock back and recall how it all began.

The son of a miner, Jack Hoggan (as he then was) was born in 1951. He left school at fifteen without qualifications, trained as a mining engineer and didn't take up painting until he was twenty-two and a girlfriend gave him a set of watercolours.

No art school love-in for him; rather, a shortage of time and money meant he learned the basics by copying from library books, everything from Dali to Caravaggio to Monet. Only in his

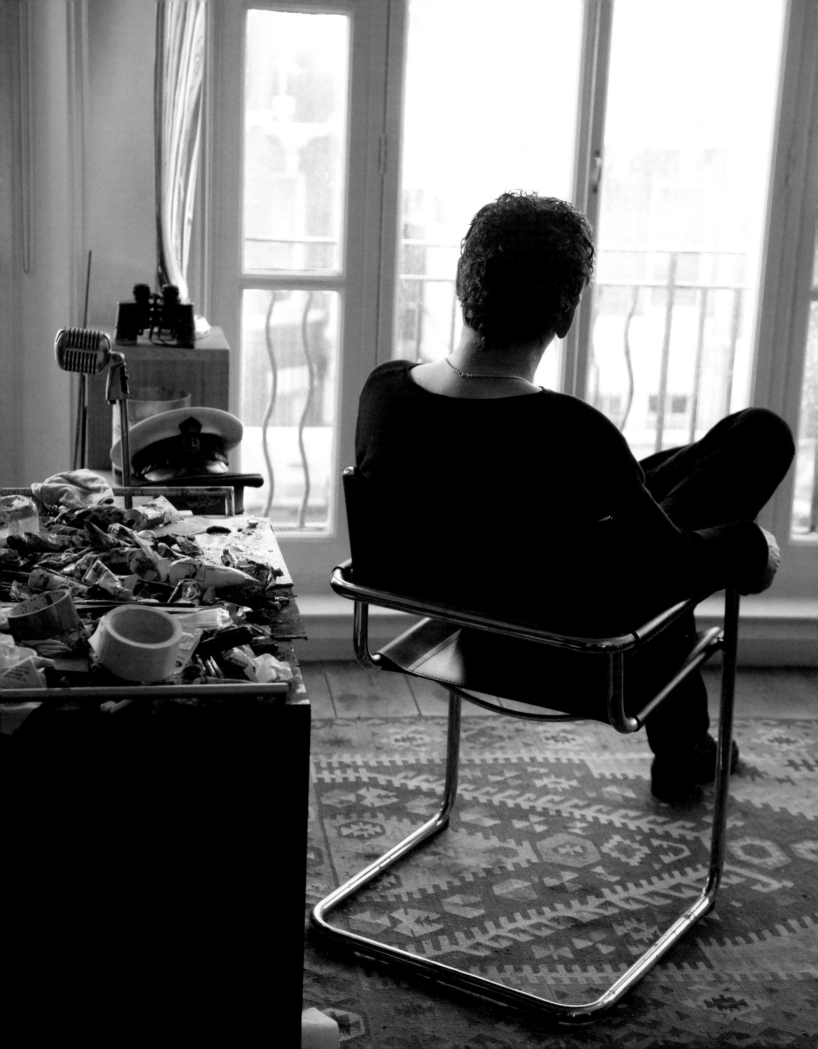

A break from work:
London studio.

mid-thirties did he start to take his art seriously, his big breakthrough coming in 1988, when he had two paintings accepted by the Royal Scottish Academy for its summer show. They sold on the first day and he had letters from three galleries offering to represent him.

By then, Vettriano (he adopted the name as a variant of the surname of his grandfather, Signor Vettraino) had long moved on from the Masters and was creating original works combining his fascination with women and his romantic view of the past. He doesn't deny the fact that he used a painter's reference manual as a basis for those early figures, but that was the purpose of the books and he had no choice.

'When an artist wants to create a painting, he will forage anywhere to get material to create it. You have to bear in mind that at that time I was sitting in Edinburgh in a small studio, no-one knew who the hell I was, I didn't have money, I didn't have access to models and I was using whatever material I could find from reference books, from magazines, from anything. I used that manual for precisely what it is there for: to help people who don't have access to models to construct something. I wasn't doing anything that the book wasn't intended for.'

By the early 1990s, Vettriano was enjoying his first taste of success and had moved to Edinburgh to paint full time. Now he could afford to hire models to pose for his paintings, but from the start he preferred to photograph them rather than paint them as they sat there.

'If I am honest, the reason I can't paint from life is a complete lack of confidence. I am self-taught, I have never been exposed to it. I never went to art school, never sat in a room with a naked model and drew her, never had a tutor come in and tell me, "You've got this right, this wrong."

'I have tried to paint with a live model, before I started painting professionally. It was in Kirkcaldy and it was an absolute nightmare because I didn't have the confidence, I was embarrassed, shy. I was worrying about whether I could nip out for a cup of tea, worrying she would be sitting there thinking "God, he's been a couple of hours now, surely he must have finished."

'The only consolation I can take from it is that my skill seems to be in both the idea and the atmosphere and bringing those aspects together. That is what I am good at, not drawing.'

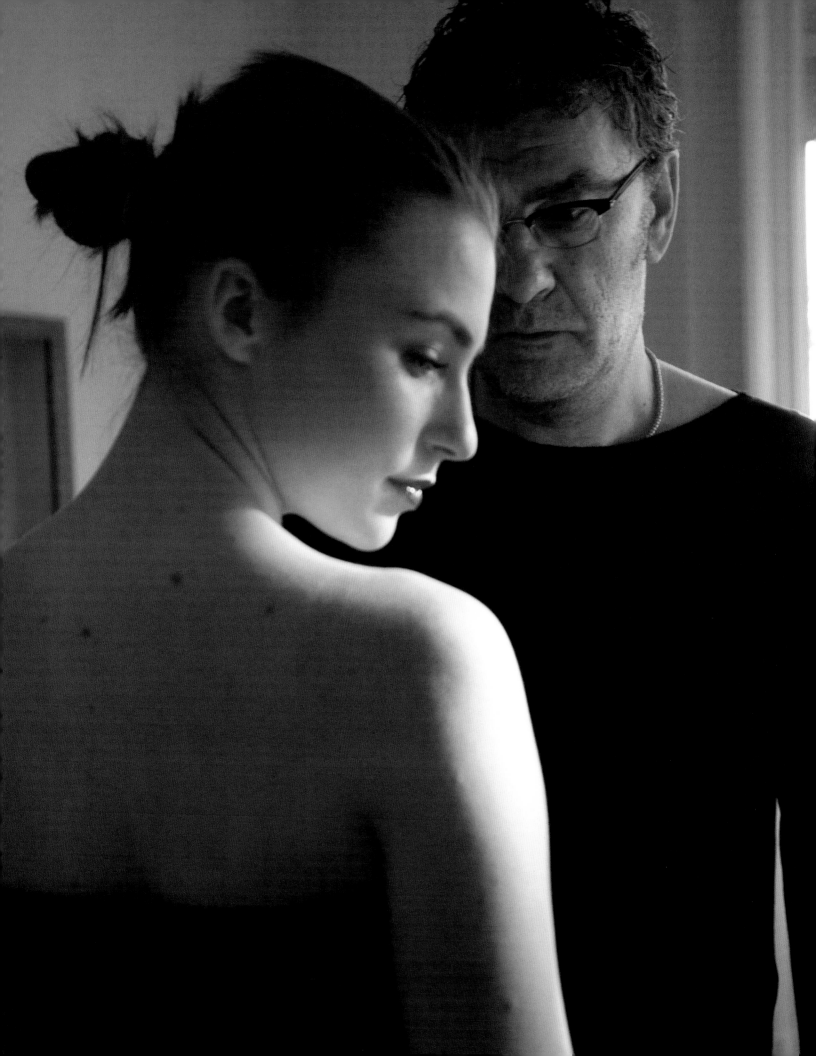

'I only paint a woman if I find her attractive.'

Given his ever-growing profile, there is no shortage of women willing to model for Vettriano today. But he will paint only subjects who appeal to him – and there have been times when he has been so taken by a passer-by that he has approached her in the street.

'There was a woman I saw near my London flat who caught my eye, so I just went up to her, told her I was a painter, that I lived nearby and that I'd love to paint her. She said: "How am I to know you're not an axe murderer?" and shot off. And I suppose she had a point.'

More successful, however, was another, more considered, approach executed in Edinburgh. 'I used to see this girl from the windows of my studio, crossing over the Dean Bridge. I'd see her quite often and I really wanted to paint her, she looked perfect for me. So what I did was put together a little pack of some of my greetings cards, an exhibition catalogue and a letter explaining that I was an artist, that I had seen her on many mornings and that I wanted to paint her. One day, I saw her coming across the street and I went out, handed her the pack and asked her to ring me if she was interested. She rang that afternoon and appeared in three of my paintings.'

'MAN AT WORK'. SELF PORTRAIT.

But that is the exception, not the rule. Vettriano prefers to have some link to his models, having met them socially or through friends and contacts. Generally speaking, they must fulfil two criteria. One is their age, the other that he sees in them something he wants to paint.

'I have always thought it was better to paint a woman in her thirties if only because she has a better grasp of the world I am trying to create. I prefer them when they are older because they have lived a bit. Some of the pictures are quite dark and it is better when a woman is older because she has developed her own sexual mindset. I think some of them are excited about it, it's a bit like them being a

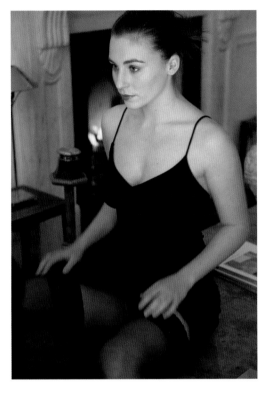

kid and being asked to dress up, or being in the movies. Most women would like to step into one of my paintings, albeit to step out quite quickly, not to get too embroiled in it.'

On a number of occasions he has been involved in – or subsequently embarked upon – relationships with those who have posed for him.

'I don't hide from the fact that I only paint a woman if I find her attractive so that is a starting point. And it doesn't take too much imagination to suppose a woman might be thrilled to be painted by me, so you have something going on already, and whether it goes further is just down to how you get on. When I meet a new model, I do get enthusiastic and there is a part of me that wants to show off to them and that makes you work harder. It's as if I am saying: "I want to show you how

good I am, how well I can do this." It's not necessarily a bad thing, it's an encouragement for me to do my best.'

Having found his model, Vettriano will discuss his ideas before photographing her. He describes the thought process behind one of his latest works, *Home Visit*: 'Just as a doctor would come to your house if you were ill, in this instance the man has called up the local massage parlour and asked for a girl to pay a house call. So how do I want to illustrate this? I thought maybe the scenario could be of him opening his front door to the girl, but I wanted to go straight for the jugular and so here we have this girl who is quite clearly posing for him. There is a bit of distance between them and there doesn't seem to be much affection. She has her legs parted and her dress pulled up and it is very sexually charged and that's the way I want to paint it, as if the man is saying to her: "Go on. Show me what you've got."'

In this painting, many of the Vettriano trademarks are on display. 'I generally like women with their hair up because it gives you the neck to paint and you can see ears and earrings, which always heightens the glamour of the scene. The

Left 'Go on – show me what you've got' – the model acts out her role for the painting *Home Visit*.

Right The cigarette, the exposed neck, the red lips and the killer heels: Vettriano trademarks all.

Following pages With the desired image held like a snapshot in his mind, Jack fine-tunes the model's pose.

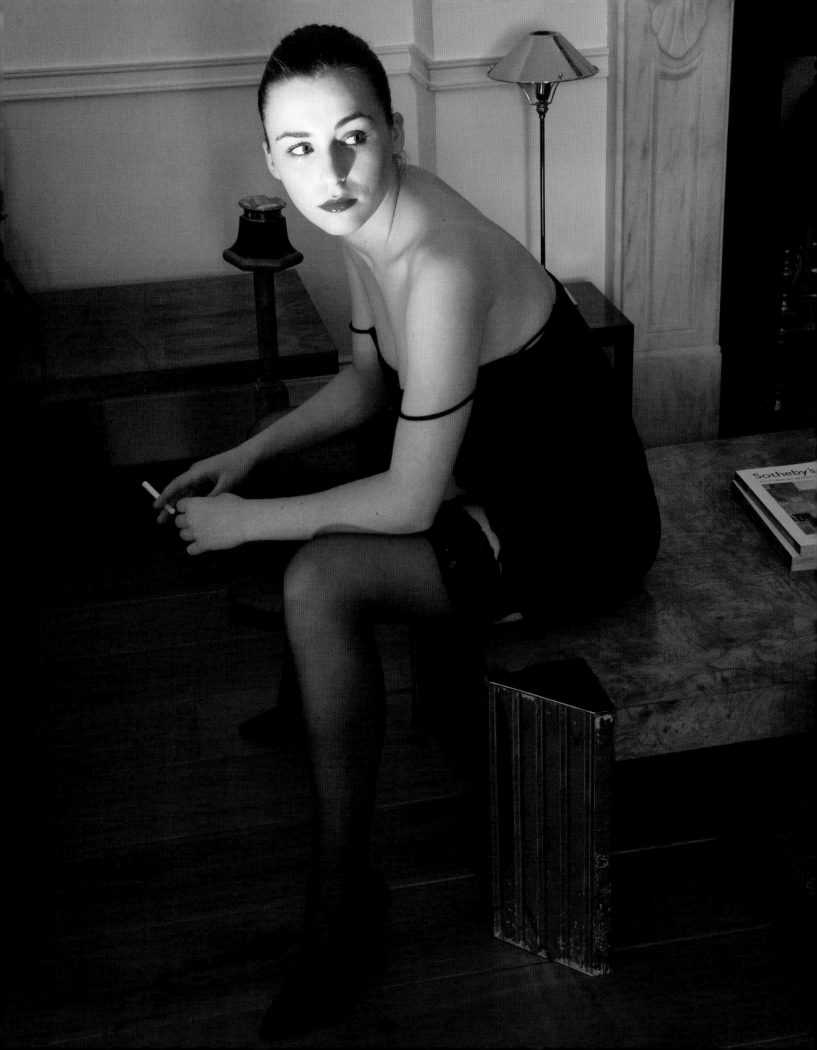

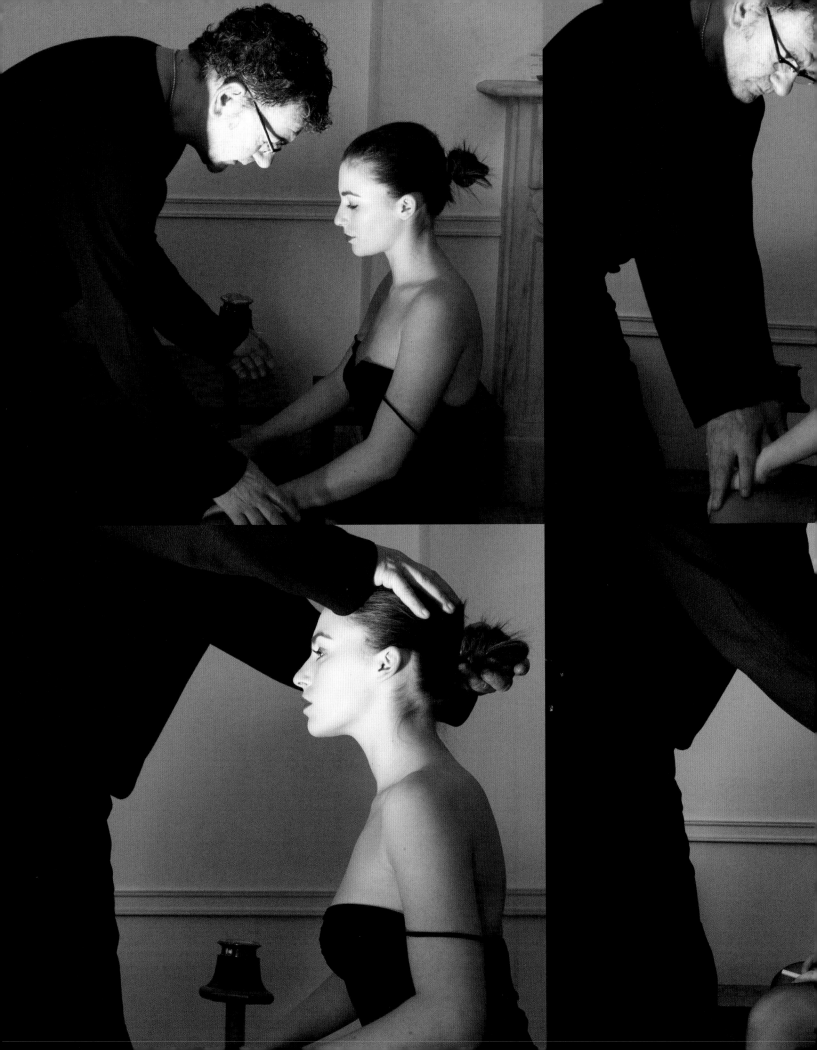

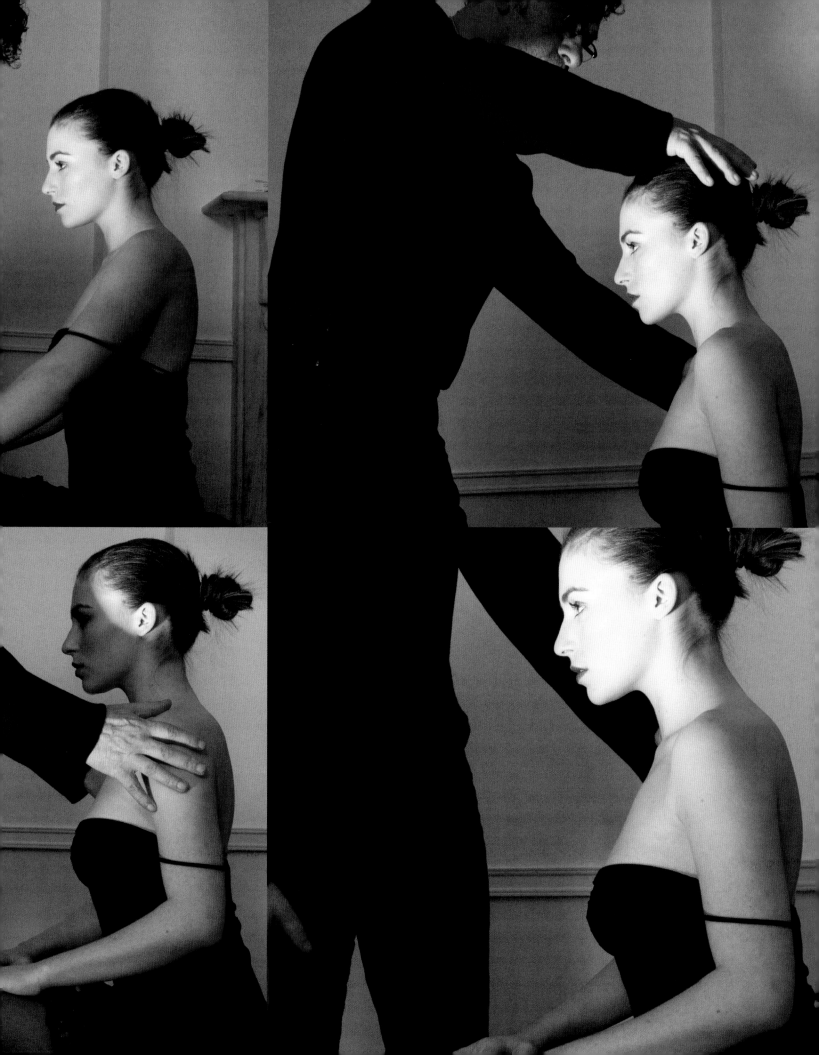

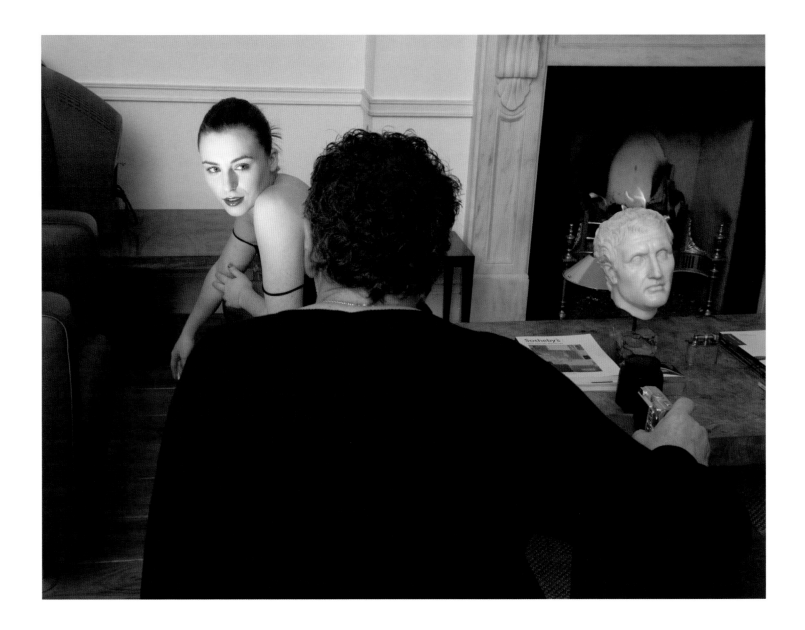

things I think lift a woman into a very desirable woman are plenty of mascara, red lips, red nails and, while I may be in a minority, smoking has always excited me. When a woman sits back with bright red lipstick and painted nails and smokes and lets a high-heel hang off the end of her toe…well, that's me gone'.

Once he is satisfied with the pose, he will hand the camera over to the model and ask her to take a photograph of himself as he plays the part of the male character. He nearly always does this and says it is for practical reasons rather than personal vanity. 'It has been suggested by my critics that I get off on putting myself in the pictures, but I just don't see that. There is no attempt to think I want to be that man. I paint myself because I am available all the time and I am the cheapest model I know'. Indeed, rarely do the males who appear in his finished works resemble Vettriano – whereas his highly acclaimed self-portraits most certainly do.

'For me, the woman is far more important. I want to paint attractive women. I don't give a damn about the men. I will spend half an hour putting a seam onto a stocking and two minutes on a man's face. I know my priorities'.

Once the photographic shoot has been completed, Vettriano will select the male and female images he most likes. (Incidentally, he has recently switched from film to a digital camera. 'If you had seen me over the years shuffling up the queue at Boots, using a false name, you'd know why. You just know the staff have seen all the pictures I have taken of girls in stockings and suspenders and they must be thinking: "Should we phone the police or is this stuff OK?"')

But before embarking on the final canvas, Vettriano will first execute a small study measuring about 12 x 10 inches. This enables him to ensure the composition is perfectly balanced.

'I will work straight from the photographs and with the small ones you can work very quickly, and if you feel someone is not where they should be, you can rub them off with a rag and move them slightly. What is nice about the studies is that they are done quickly, and if everything is where it should be, they have a lovely spontaneity about them'.

Once happy, he will prepare a bigger canvas (his preferred size is 24 x 20 inches) by priming it with a deep orange colour, a technique he borrowed from Monet. 'When you look at some of

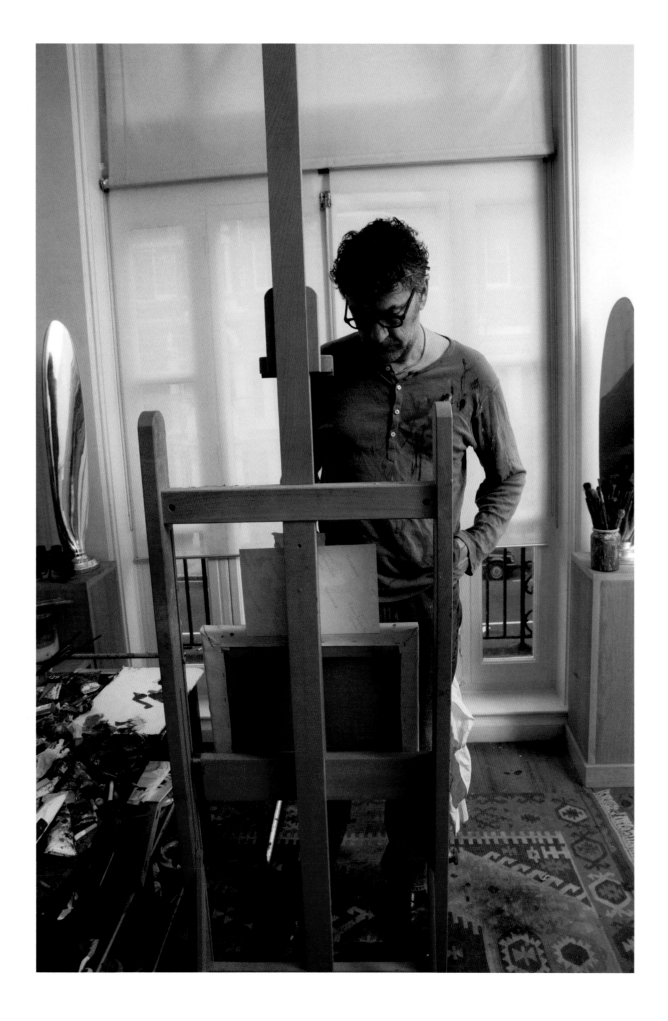

his paintings close up, you can see little gaps where there is bare canvas and there is a warm, orange colour. When you stand back it works very well, whereas if the canvas is white and it shows through, it is strangely jarring.'

Vettriano, a poor sleeper, rises every morning at dawn and will be seated at his easel at 6 a.m. He will remain there until the picture is finished – however long it takes. This focused way of working allows him an overview and control he finds essential, while also allowing him to manipulate the paint in a way that most suits his style.

'I couldn't just do a tiny section at a time, a man's jacket, or a head,' he says. 'I have to do it all at once because only then do I know it is tonally perfect. So what I do is block the whole canvas in, by which I mean roughly paint out the shapes of the scene, the figures and the setting, and then I take a very, very soft brush like a woman's make-up brush, and run it over the surface. What this does is get away from a sharp line, a bit like putting a bit of gossamer over a camera lens and softening everything.'

As the hours pass, the painting will gradually come to life as Vettriano injects light and shade into the image. 'When you first put paint on, it tends to bleed into the colour it is next to, but there are wonderful things that happen to paint when it starts to dry,' he explains. 'If you put it on and don't touch it for ten hours, you can do much more with

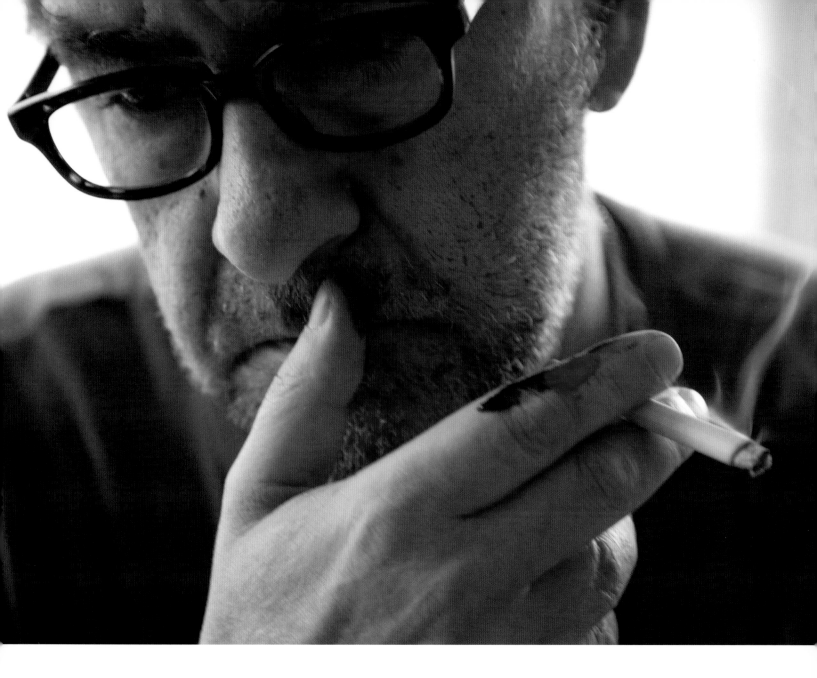

From dawn to dusk and beyond, Jack paints until the picture is completed.

it because it has got really tacky and you can drag it really easily and get some wonderful effects.'

If all goes well, the painting will develop as a whole, rather than in sections, something that is aided by the relatively small canvas size. 'The bigger it gets, the more demented you become because you get quite manic as some bits are coming forward quicker than the rest – you can drive yourself mad trying to get it all to come forward at the same time.'

His biggest canvases were painted for Terence Conran's Bluebird restaurant in London and measured 60 x 30 inches. 'They drove me absolutely crazy. Unlike some painters, I like to sit and paint, and if a canvas is that size, you have to

get off your backside and get back and back and back and I don't like that. I did have an awful sense of losing control, and it is not a nice feeling because it takes away some of the joy and you feel yourself panicking.'

Once the painting is completed, Vettriano, whose studios are located within the living areas of his homes, will simply turn the easel around so that over the next hours or days he can keep glancing at it.

'If you know you've done something good then there is a lovely sense of satisfaction. I will usually put the finished painting somewhere close to where I am relaxing, look at it and say to myself: "Yeah, that's pretty good."'

HOME VISIT A STUDY.

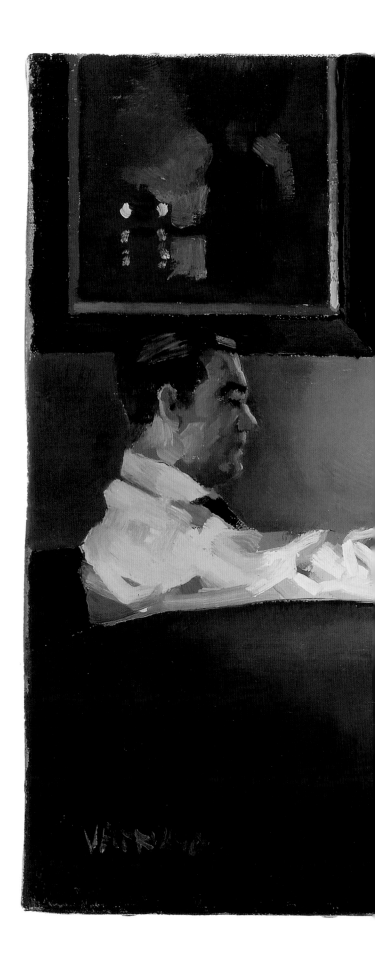

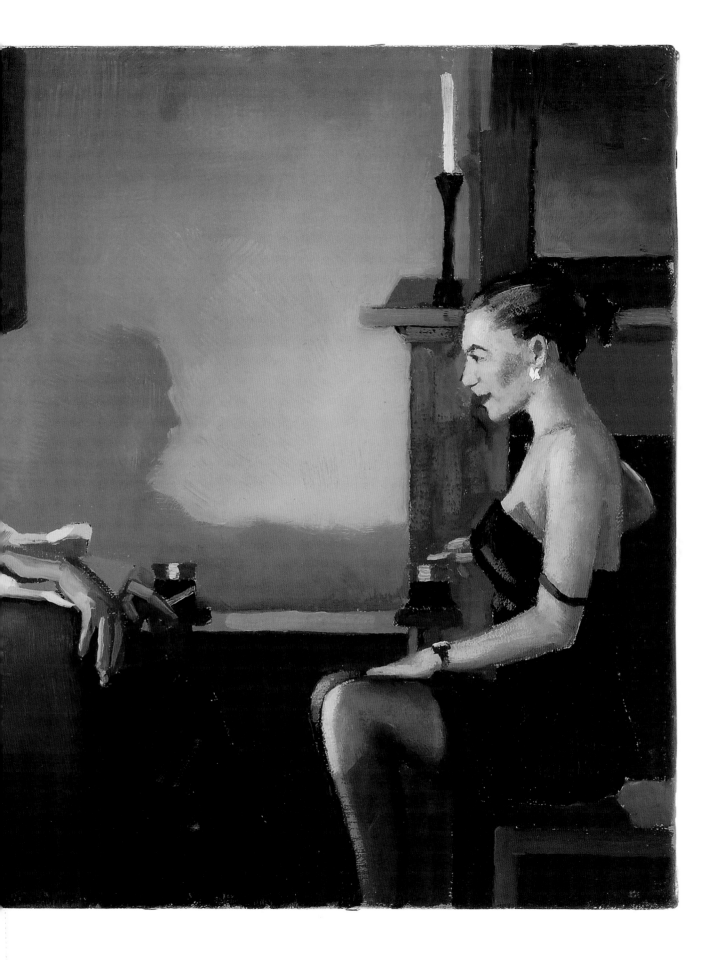

The Props. The Model.
The Painting.

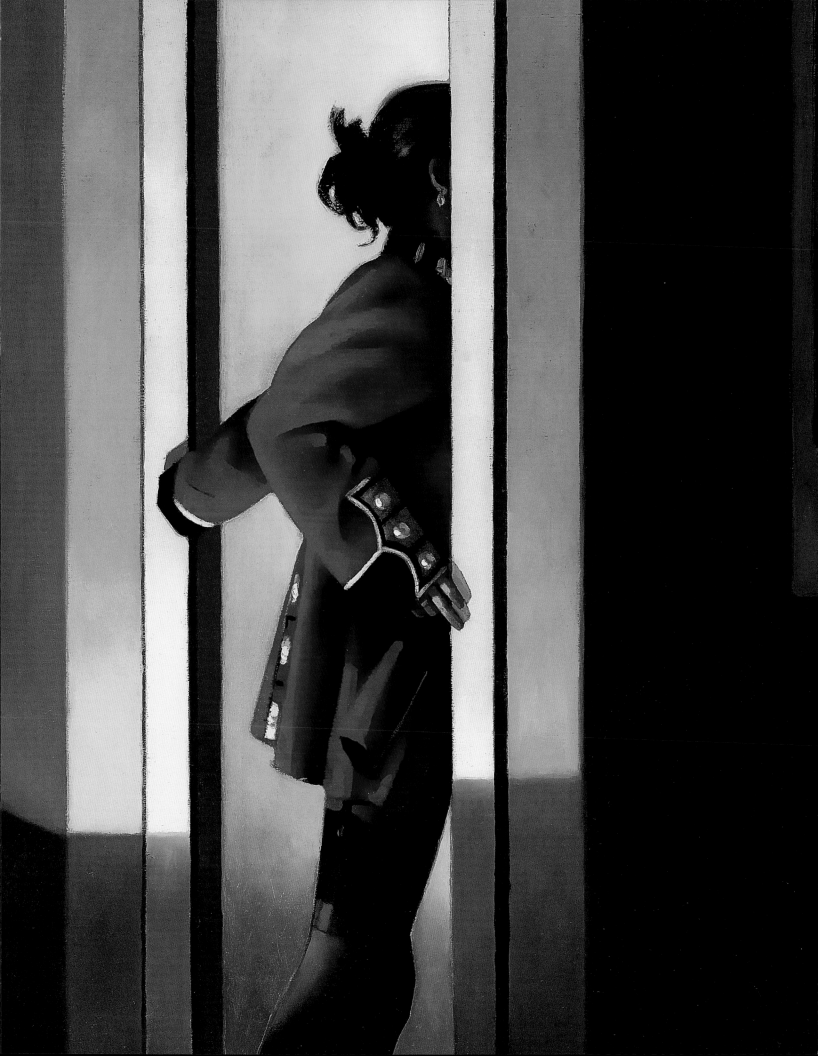

SURRENDER
The completed painting
and a study.

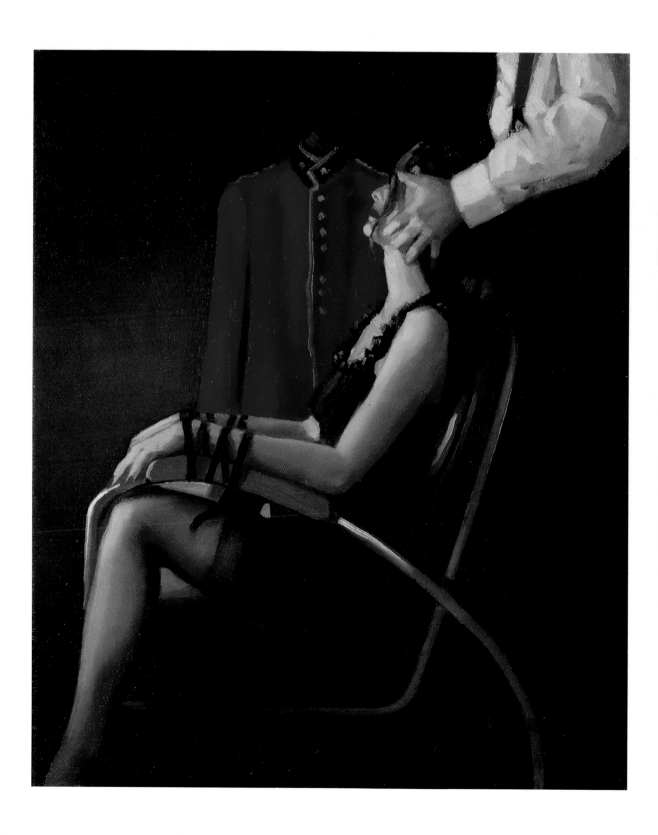

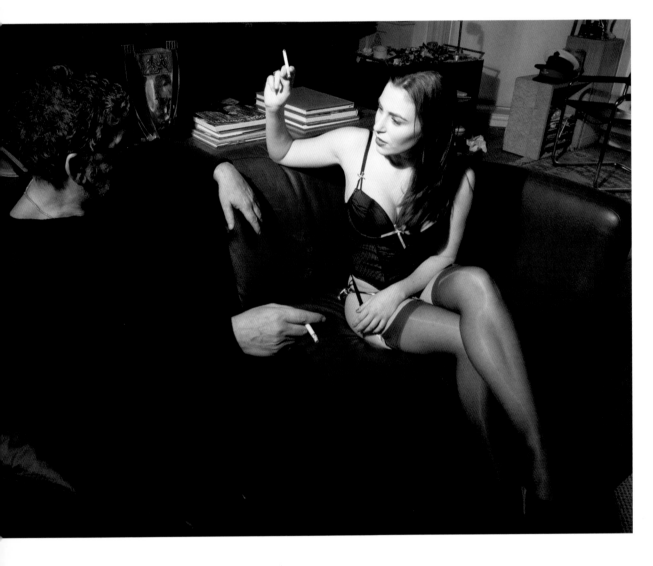

'When a woman sits back with bright red lipstick and painted nails and smokes and lets a high-heel hang off the end of her toe... well, that's me gone'.

A VERY MARRIED WOMAN

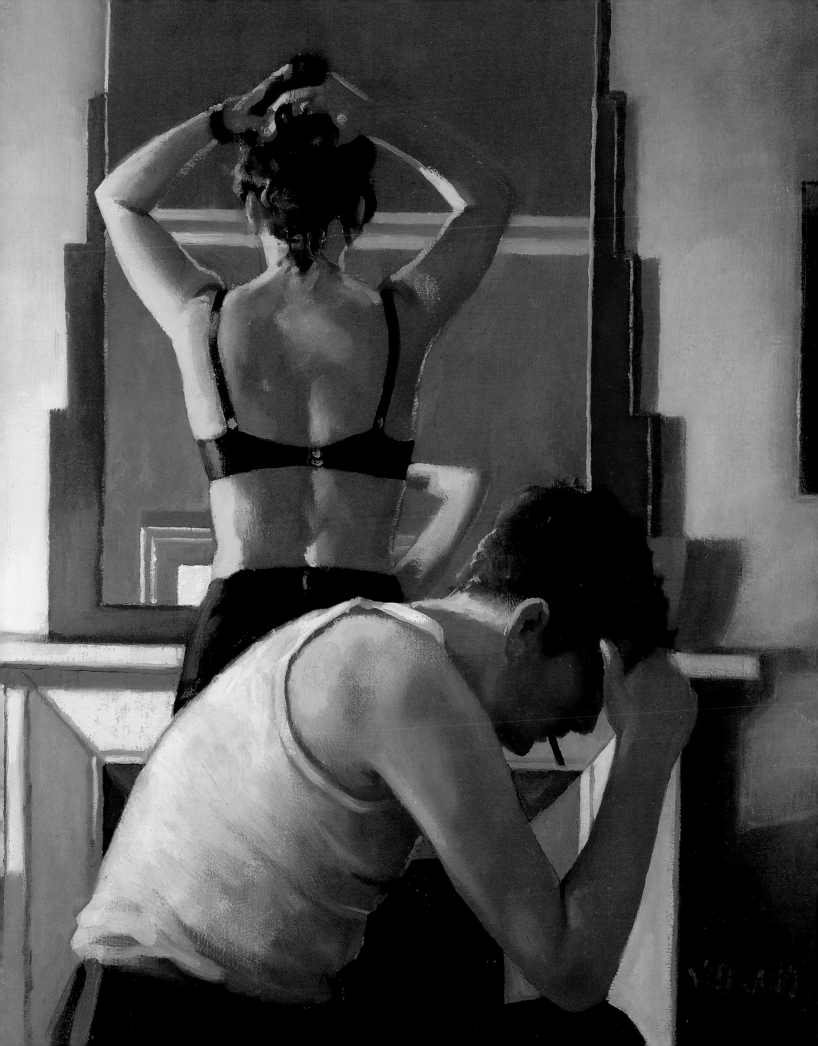

DEVOTION

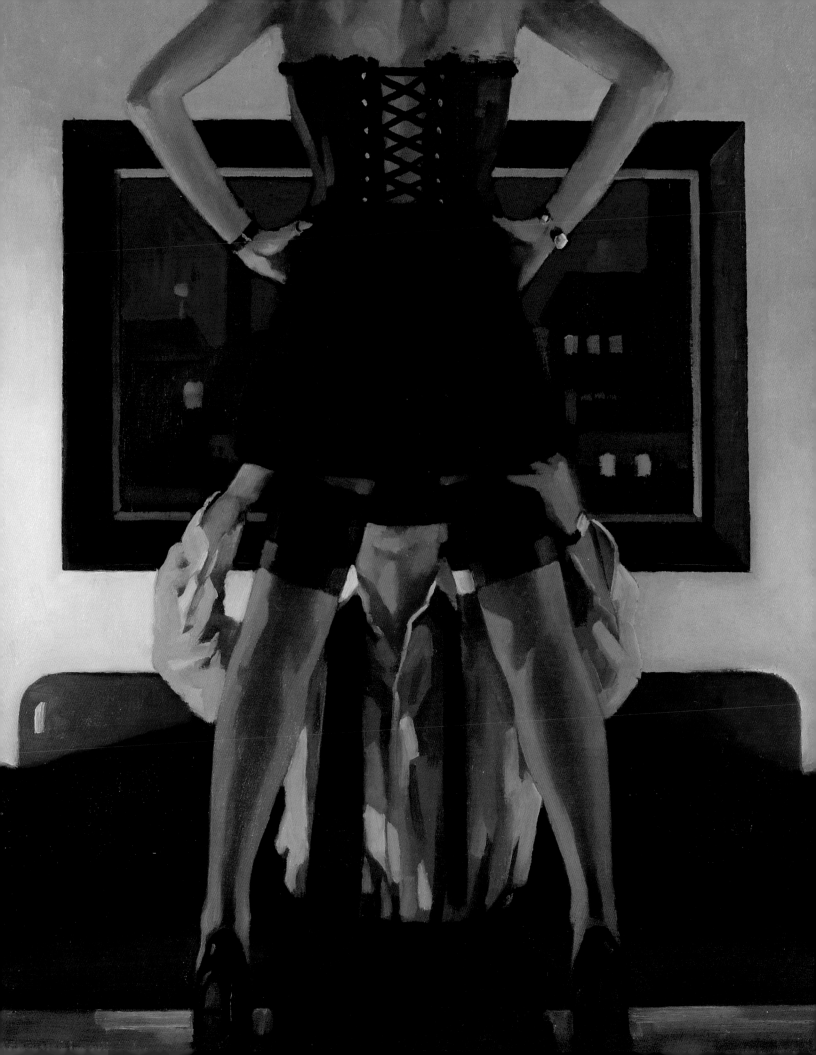

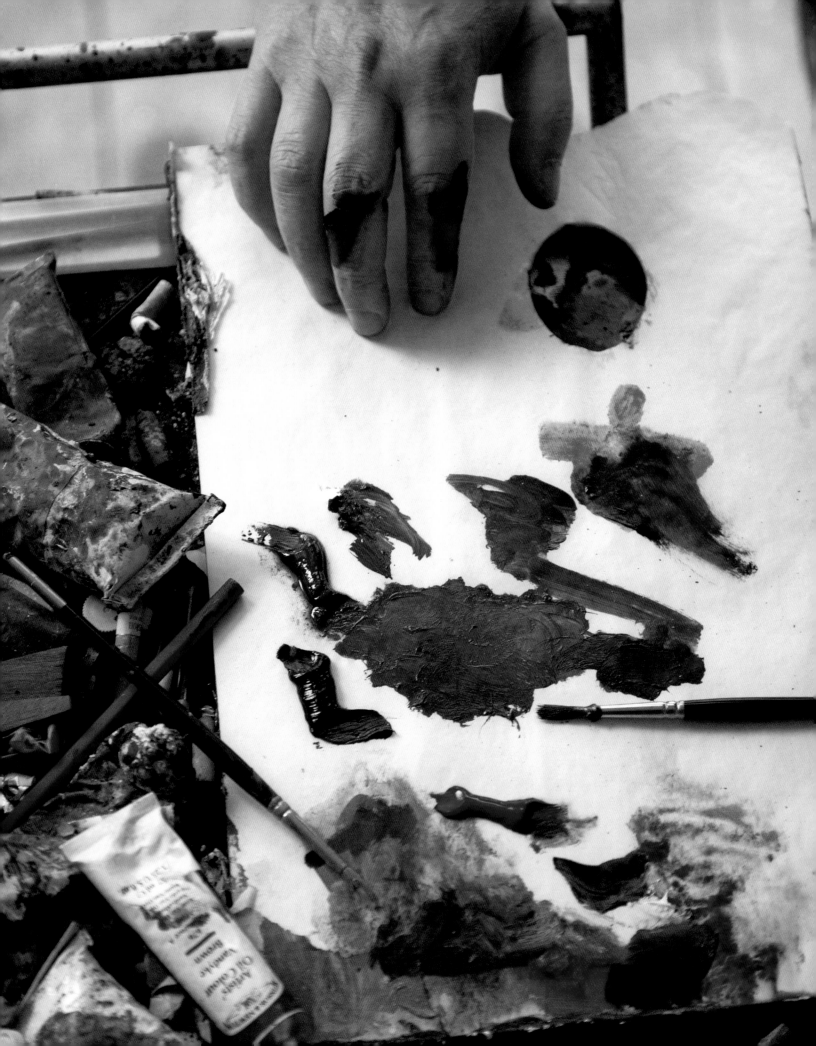

Left Palette detail.
Right Paintbrushes.

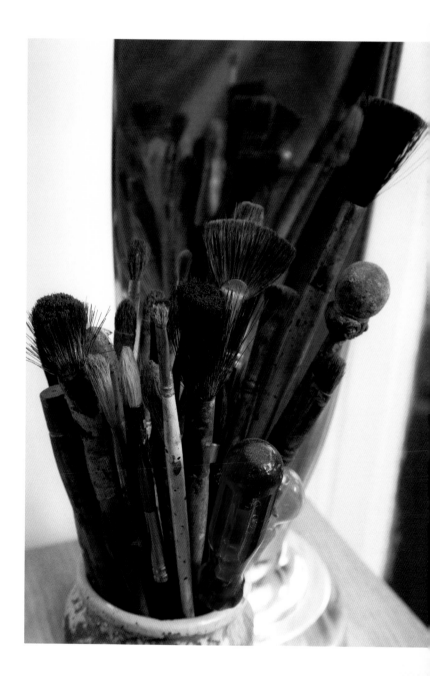

Shadows and light in
Jack's London studio –
always two distinctive
features of his work.

Following pages
Dressed to paint, Jack in
his London studio.

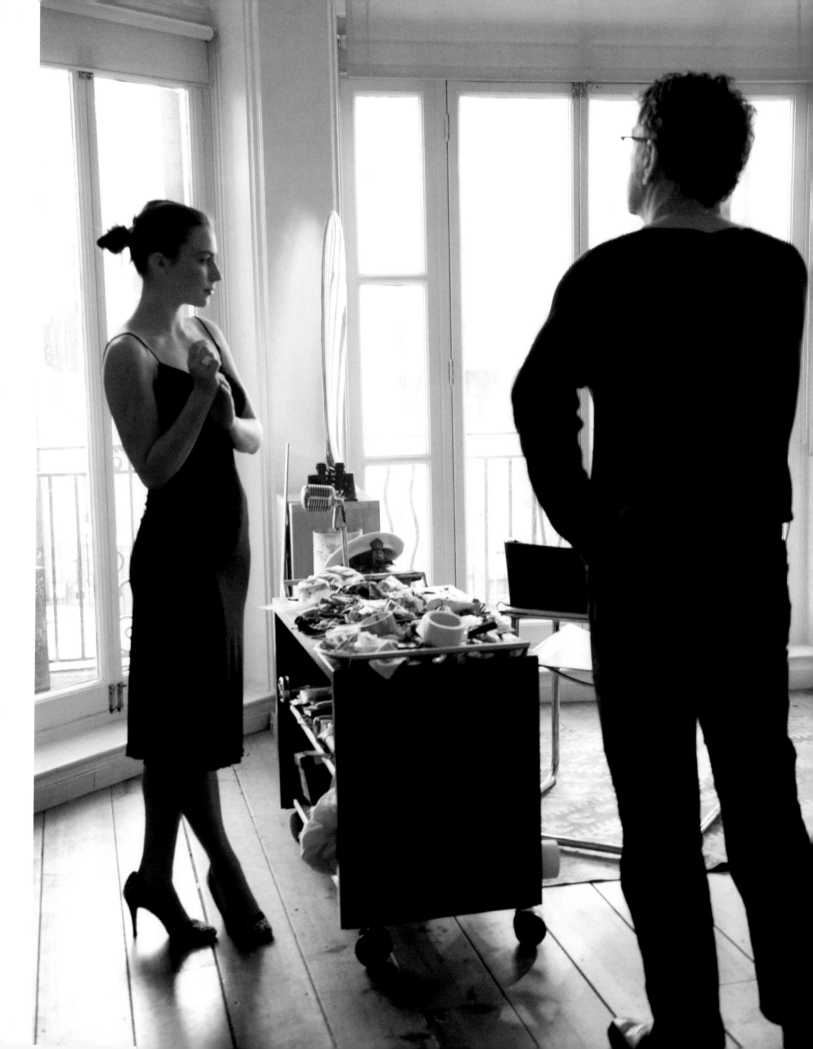

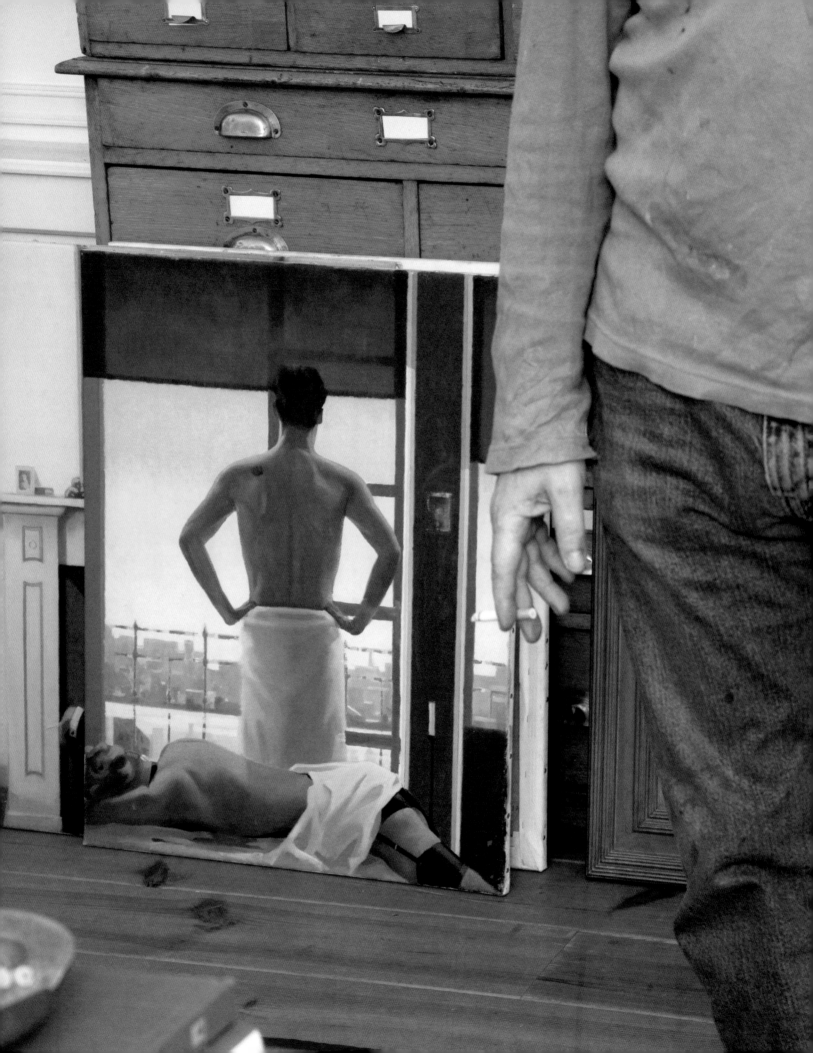

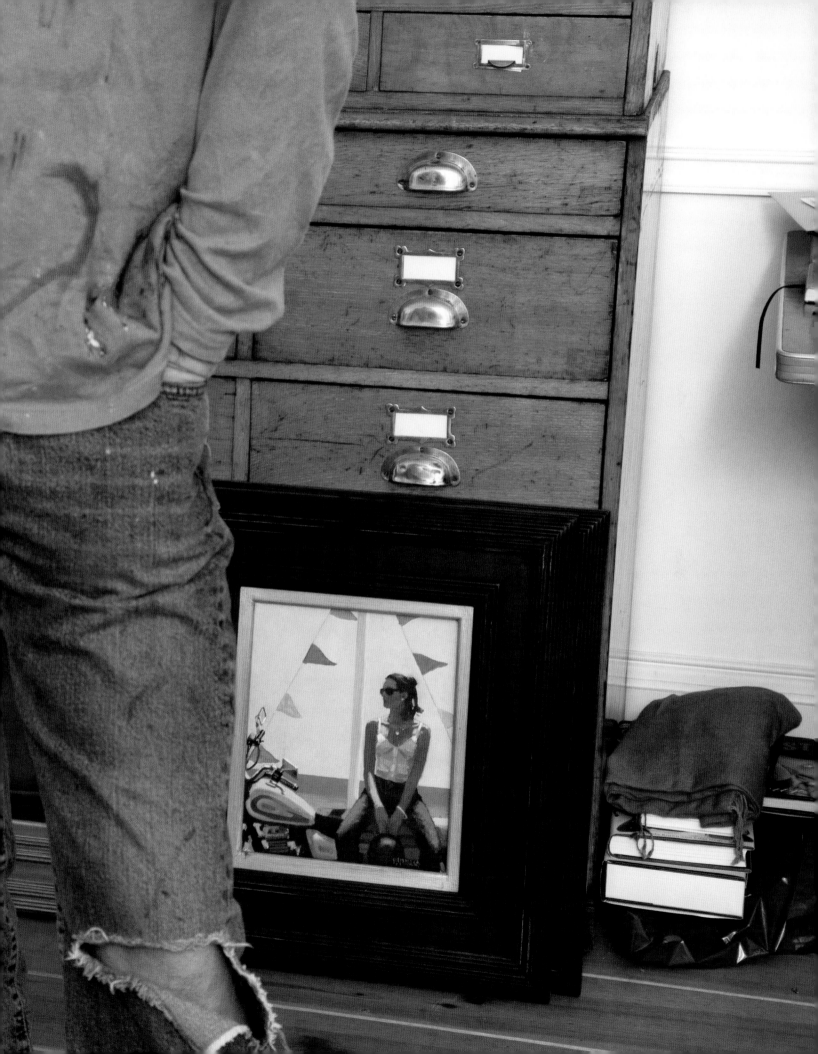

'I will spend half an hour
putting a seam onto a
stocking and two minutes
on a man's face. I know
my priorities'.

Right Working attire:
London studio.

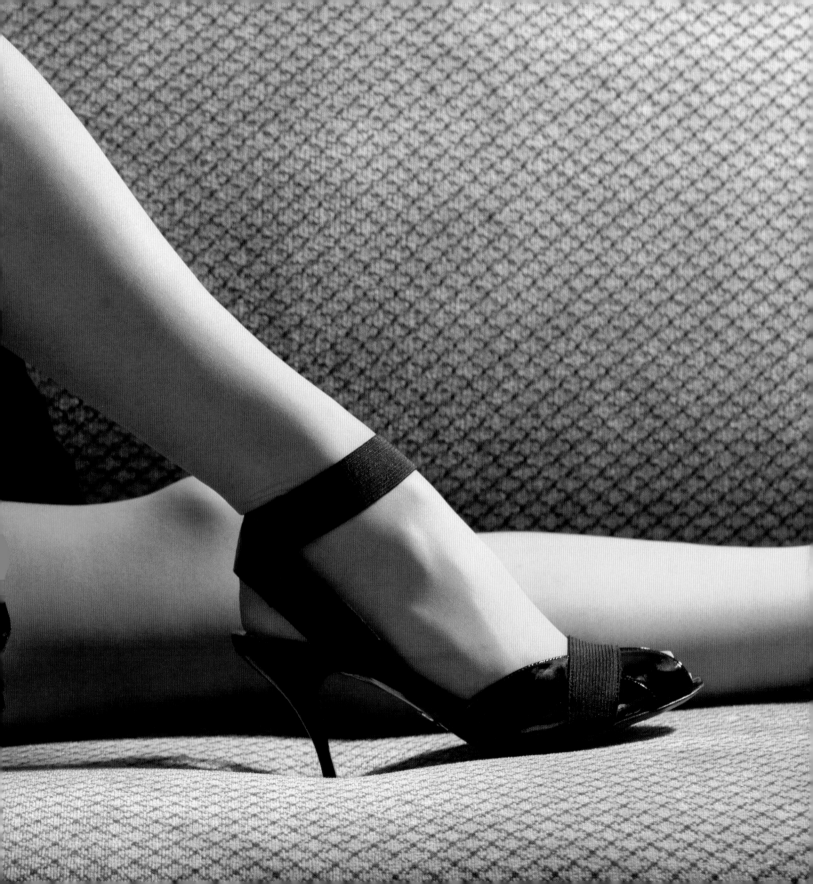

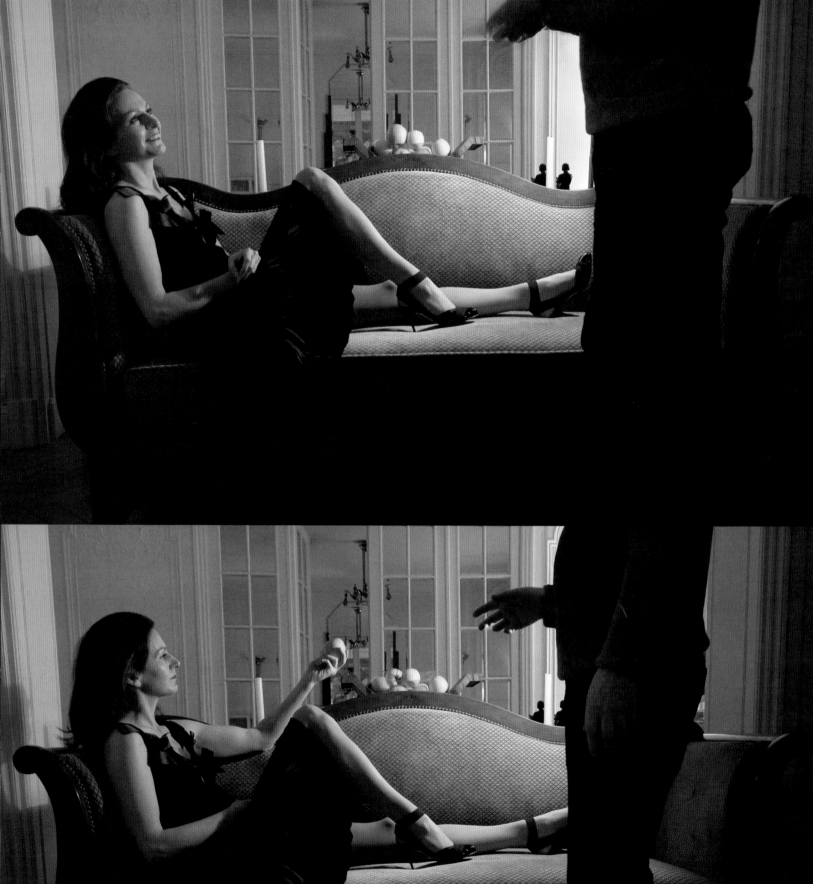

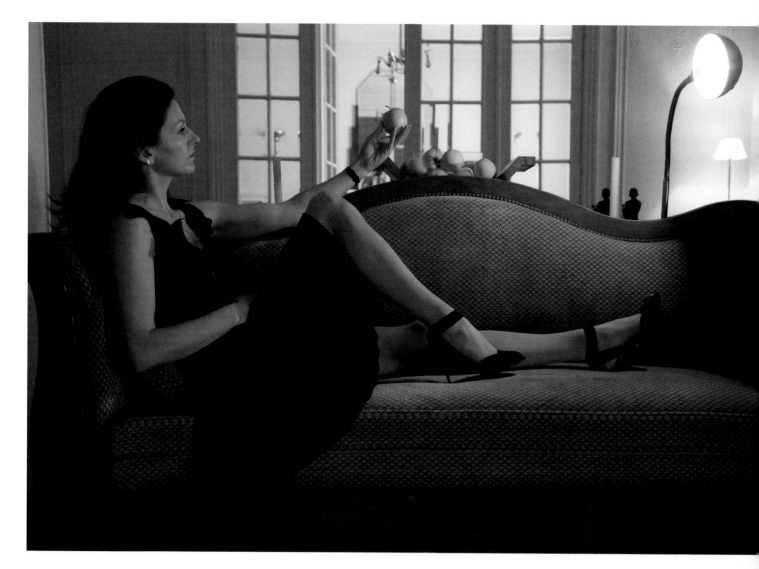

Searching for the perfect
pose; setting the scene for
a painting to be titled
Original Sin.

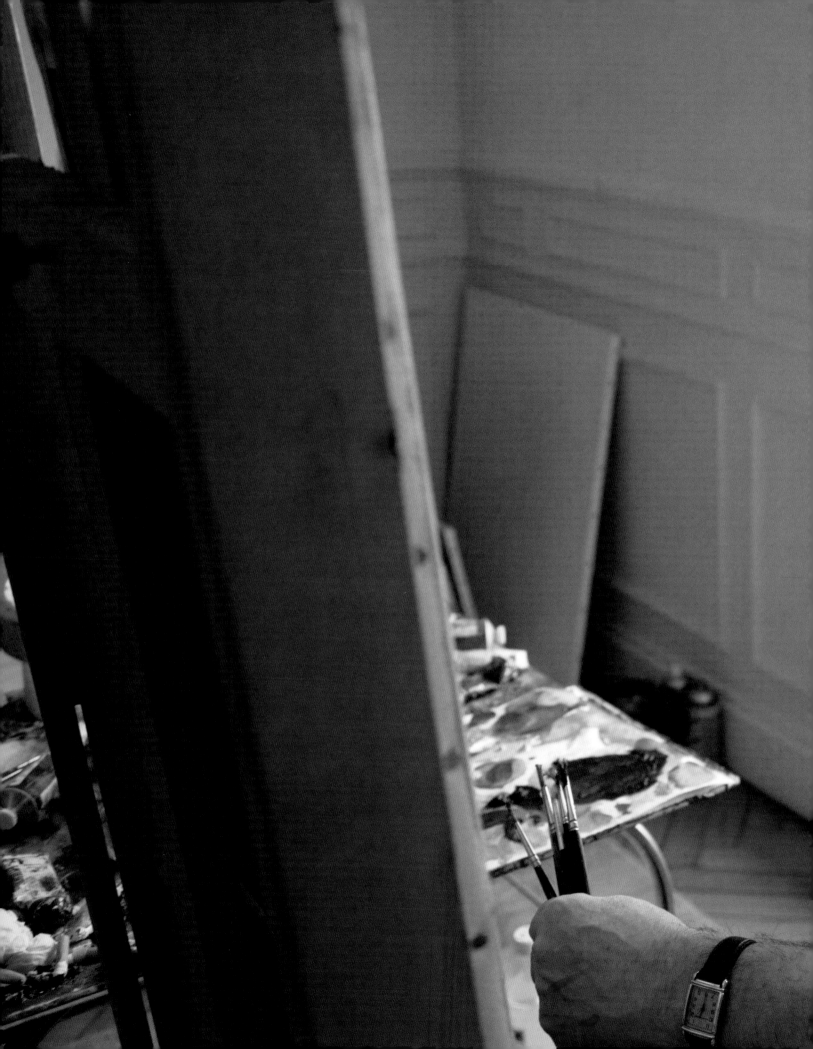

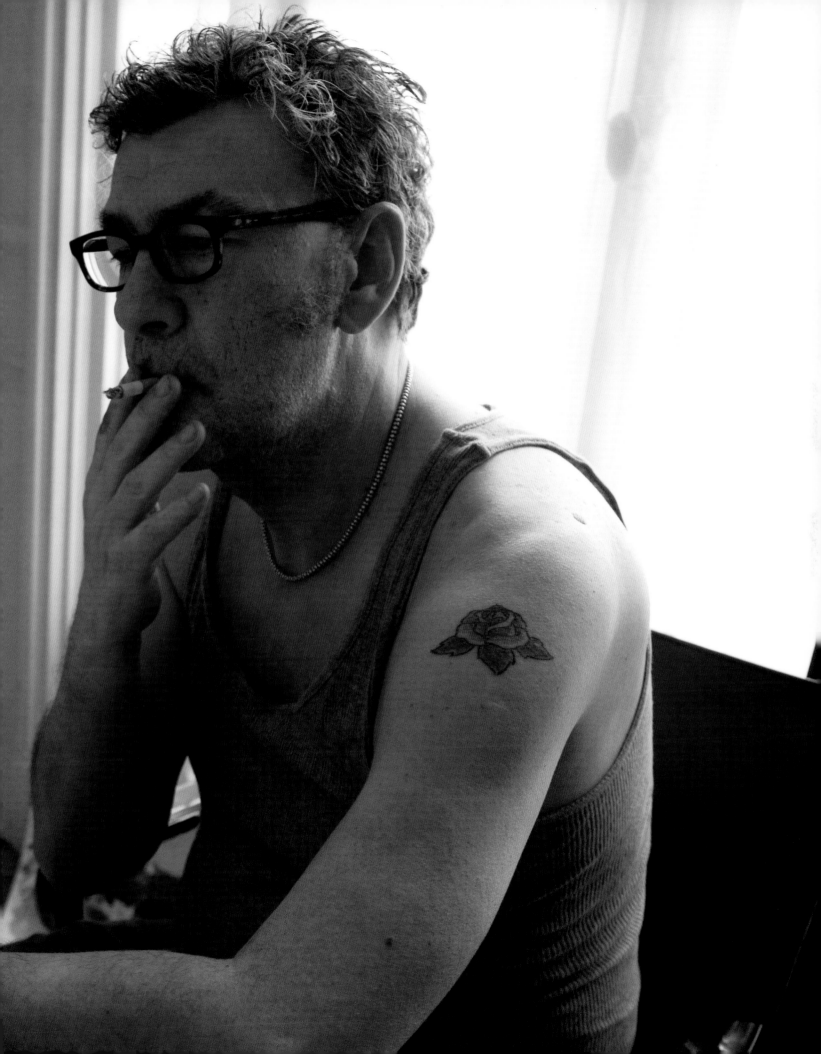

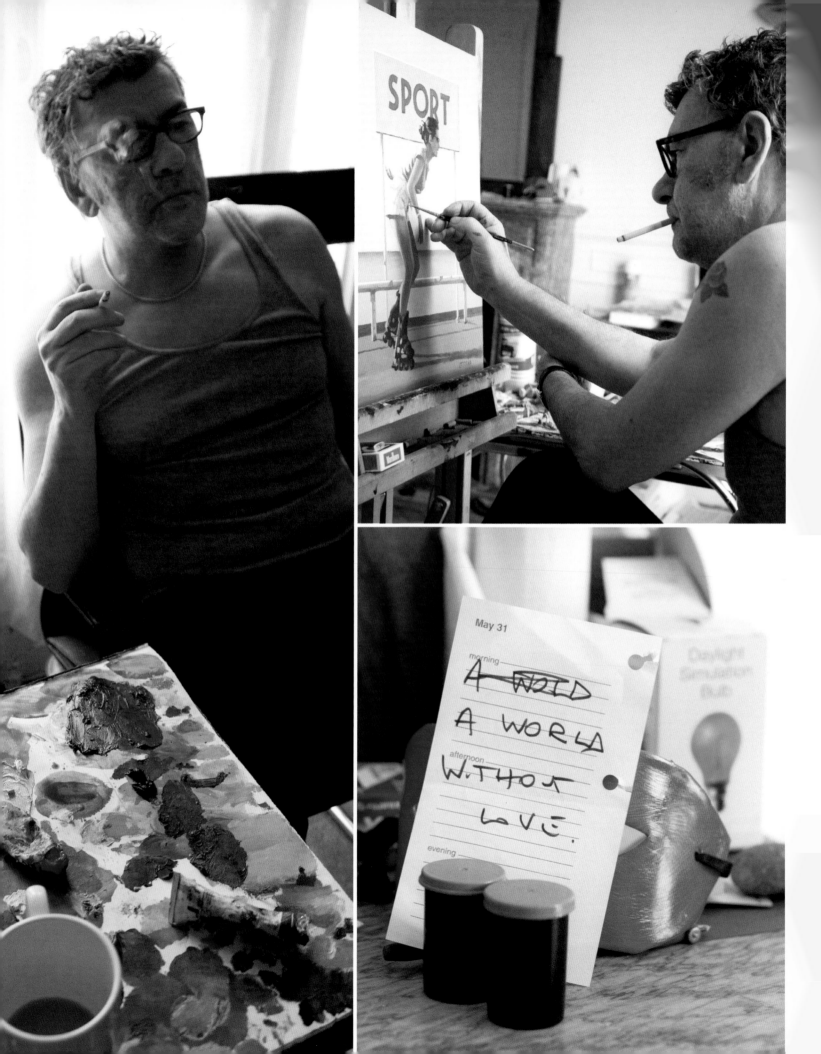

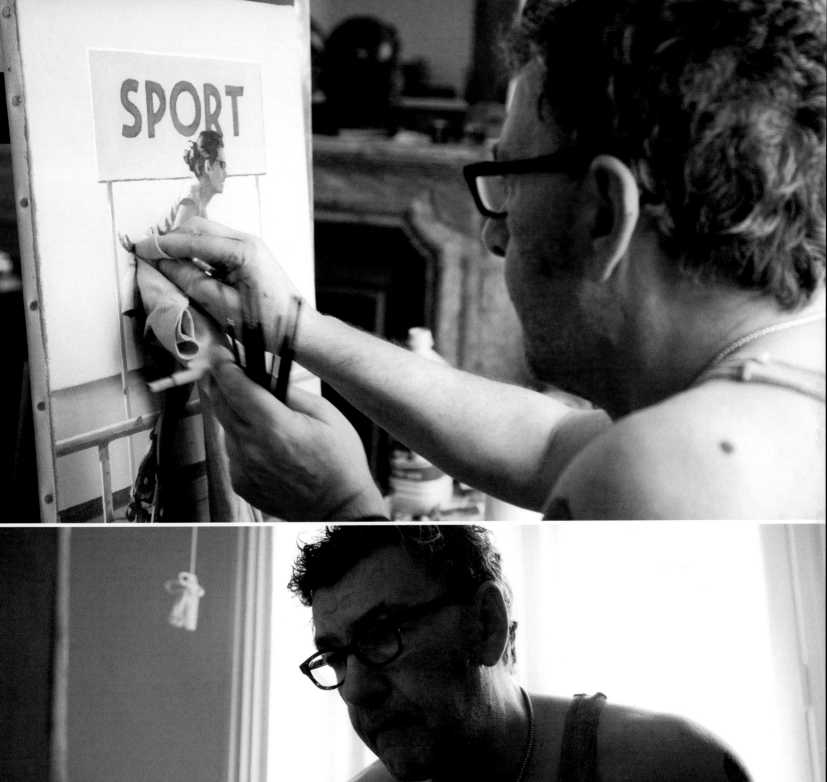
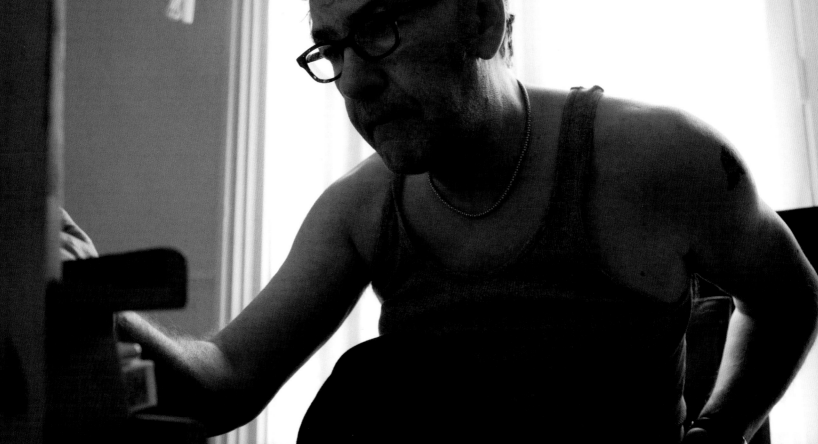

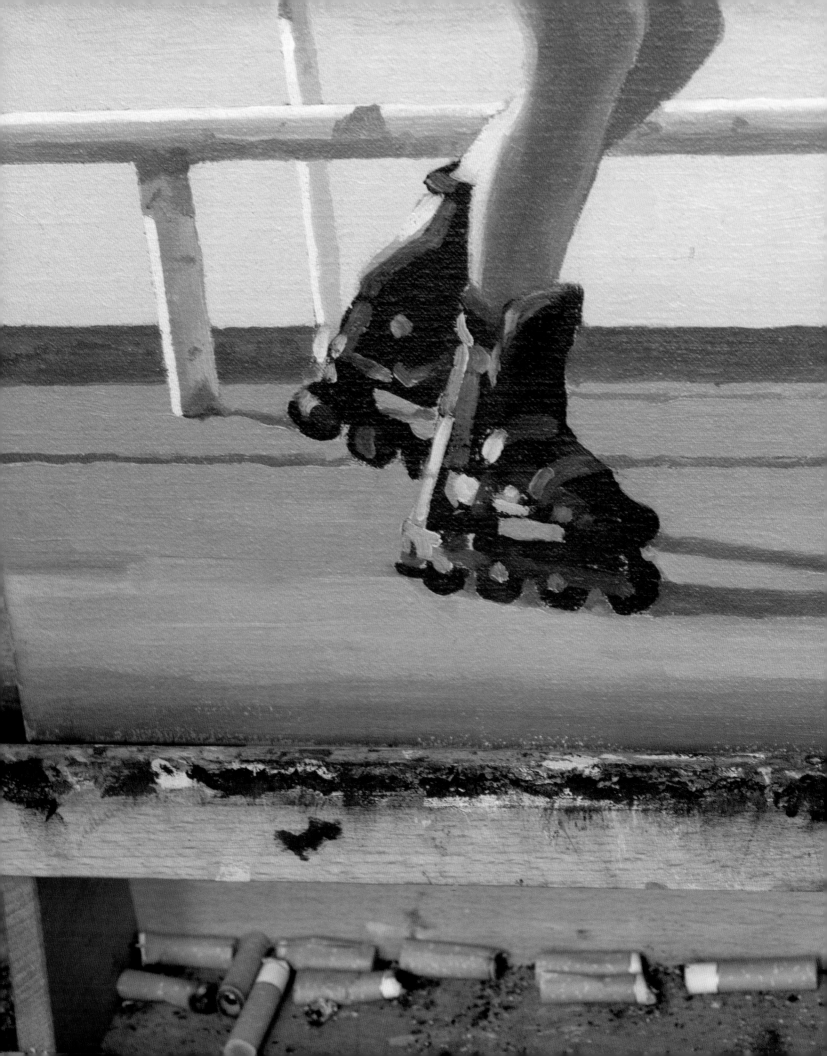

Pages 58–61 'I couldn't just
do a tiny section at a
time… I have to do it all
at once.' Jack puts the
finishing touches to *Blades*
one of his most recent
paintings.

Page 62–63 Signing off:
detail from *Blades*.

BLADES

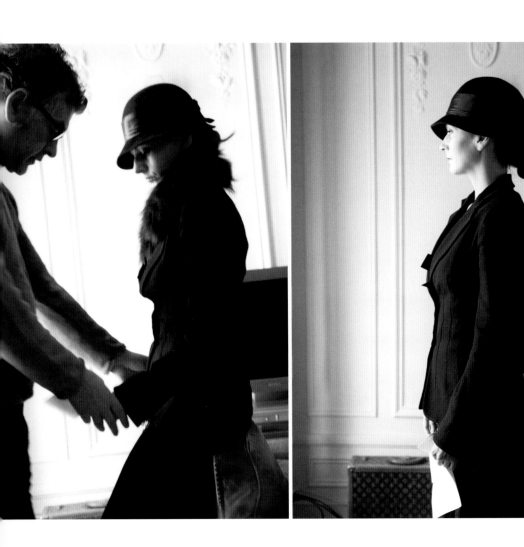

'Critics have often said that my work is like a scene out of a movie and of course, that is what it is. Whereas Martin Scorsese wants to do an entire film, I just want to do a frame, one shot'.

**LA FEMME AU
CHAPEAU NOIR**

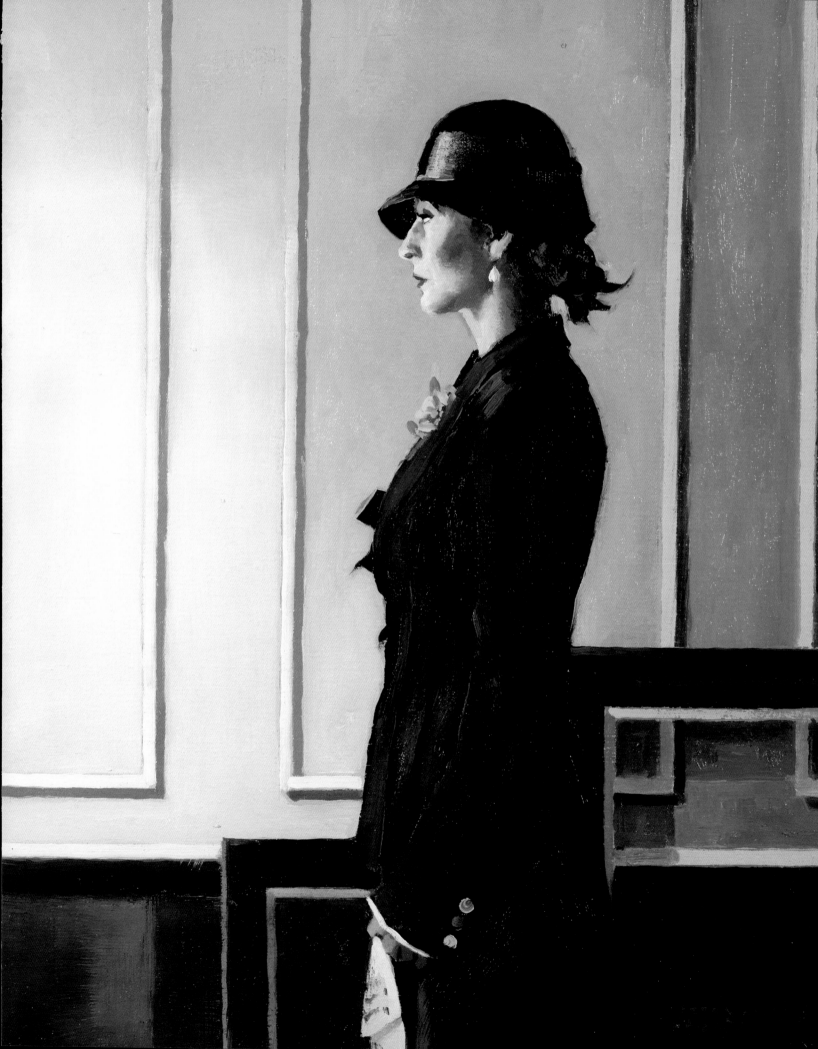

Palette detail

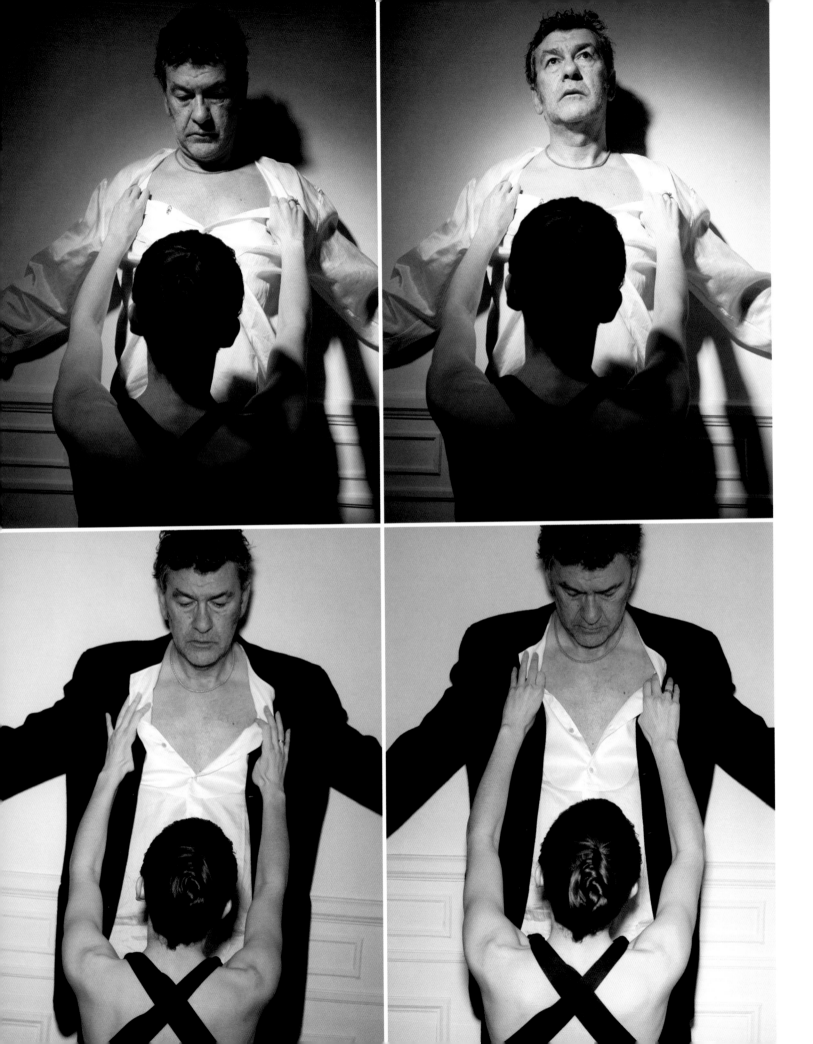

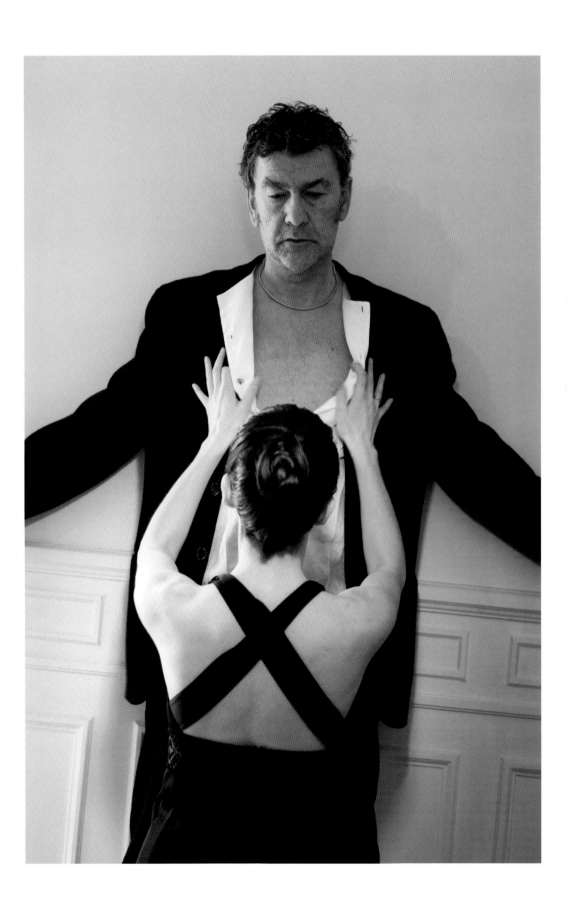

Jack poses for photographs in Nice and plays the male lead – 'not because I want to be that man, but because I am available, the cheapest model I know'.

Study for
THE ILLUSTRATED MAN

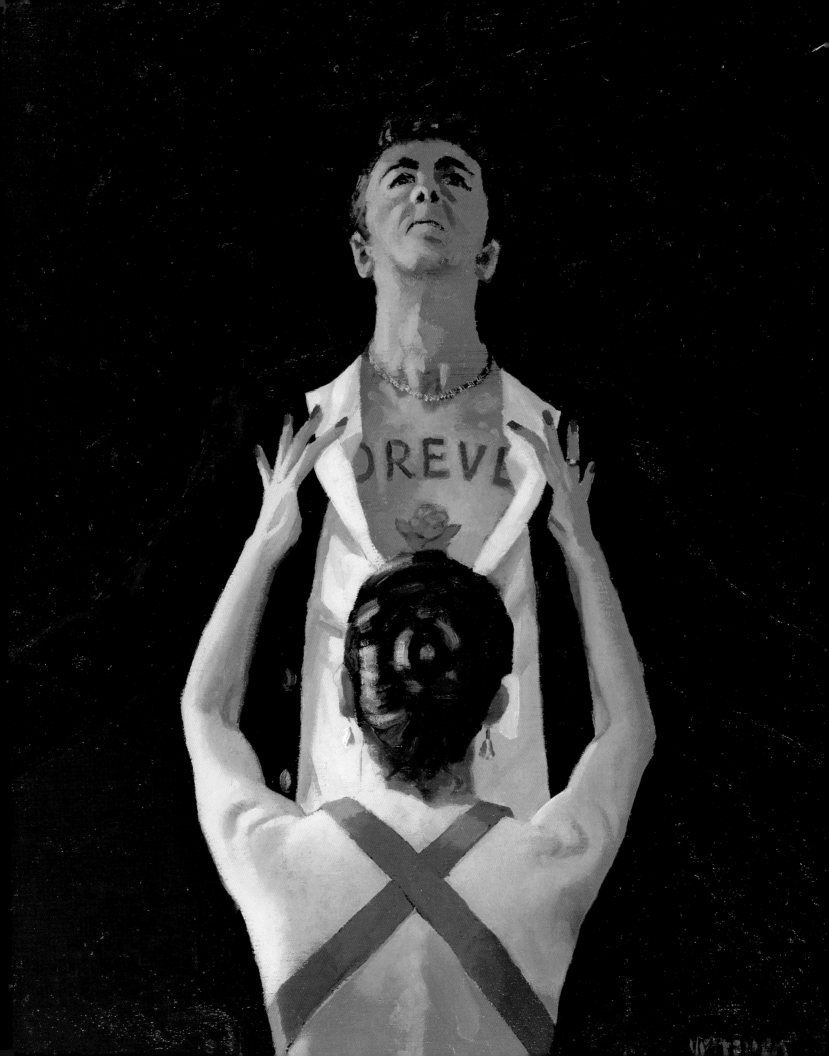

PART TWO

A SENSE OF PLACE

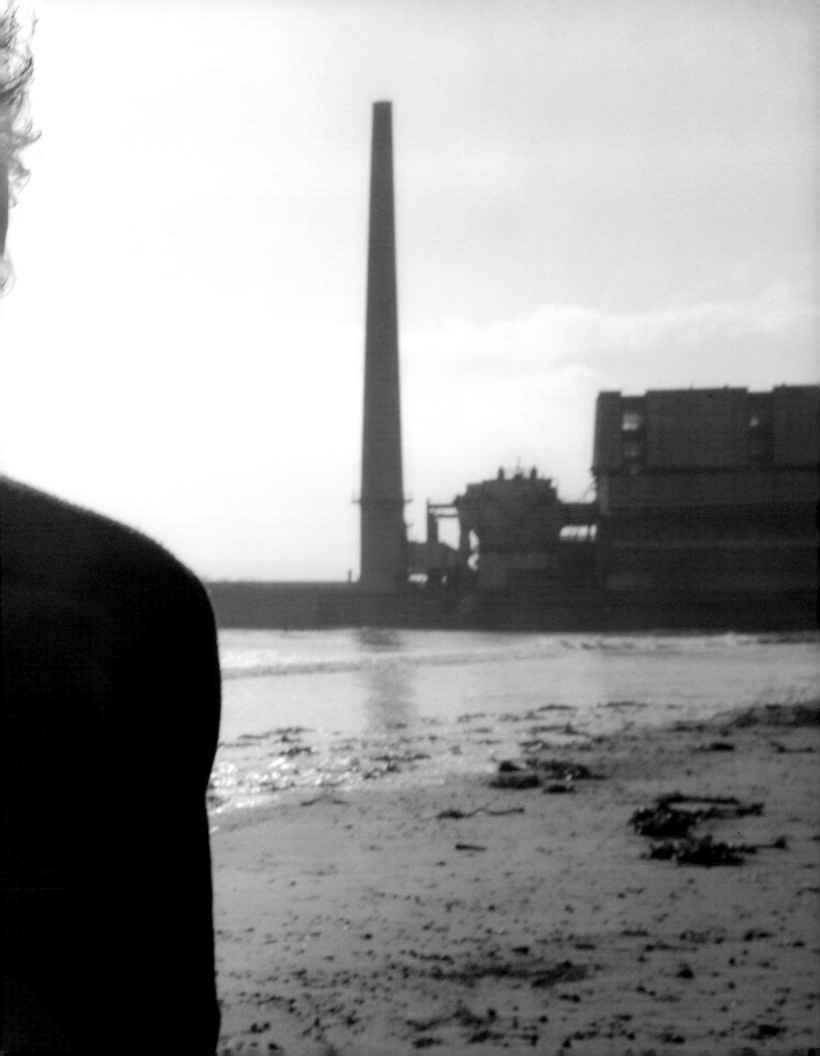

In a corner of a car park overlooking the Firth of Forth, a rust-pocked sign proclaims: 'Welcome to Leven – The Sun's Own Favourite Resort'.

Except for a burger van and a limping dog, the place is deserted and it's hard to imagine anyone visiting regularly. The sun included.

But Vettriano's been coming here for as long as he can remember, and from time to time he likes to return, to wander along the promenade that he has known as baby, boy and man.

As ever, to the right, a couple of hundred yards away, the chimney of Methil power station towers into the sky. It's shut down now, but when Vettriano was young it pumped smoke into the sky day and night, burning the coal his father Bill, a miner, spent a lifetime digging. It is a brutally functionalist building from the Sixties, and its bleak starkness is further emphasised by the fact that it sits at the head of a stunning beach – golden sands running eastwards as far as the eye can see.

Function and form. That's the way it is in these parts, and it's also how Vettriano's life unfolded: working-class, realist grit juxtaposed with the dreaming optimist, the miner's son ever-hopeful that adventure lurked around the next corner. It's a mix that informs who he is and defines his paintings, and no-one appreciates it better than the artist himself.

'I like coming back because this is the place that made me who I am,' he says, his accent as thick as the cups of tea served in Johnny's Bingo Hall on the seafront. 'In Scotland, people talk about 'ma ain folk', my own people, and these are ma ain folk around here, where I grew up. There is just something comforting about being somewhere that you know so intimately, where you know everything.'

Admittedly, nowadays Jack returns home to Fife only occasionally. In the town of Kirkcaldy, he keeps an apartment in what used to be the head office of a local linoleum firm (the wood-panelled boardroom is his beautifully appointed drawing room), but he spends just three or four weeks there a year. The rest of his time is spent in London and Nice, the latter providing a base for almost eight months of the year. He likes it there, likes the feel of the sun on his back, the al fresco eating, the food markets and the antique shops that he has plundered to furnish his Art Deco flat. He likes the architecture and the people, the glamorous

Previous pages Jack on the beach at Leven.

Right Methil power station.

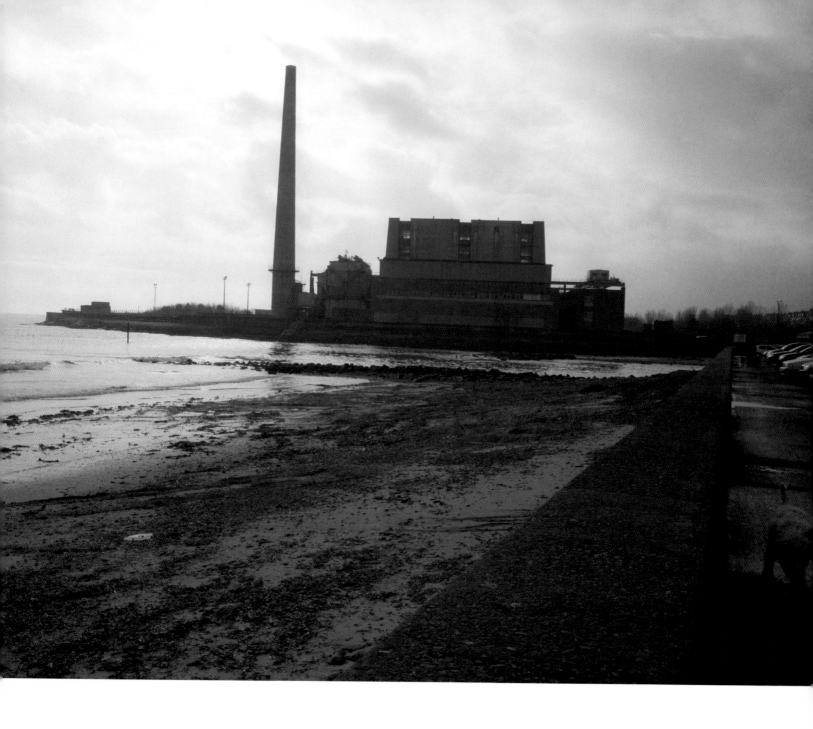

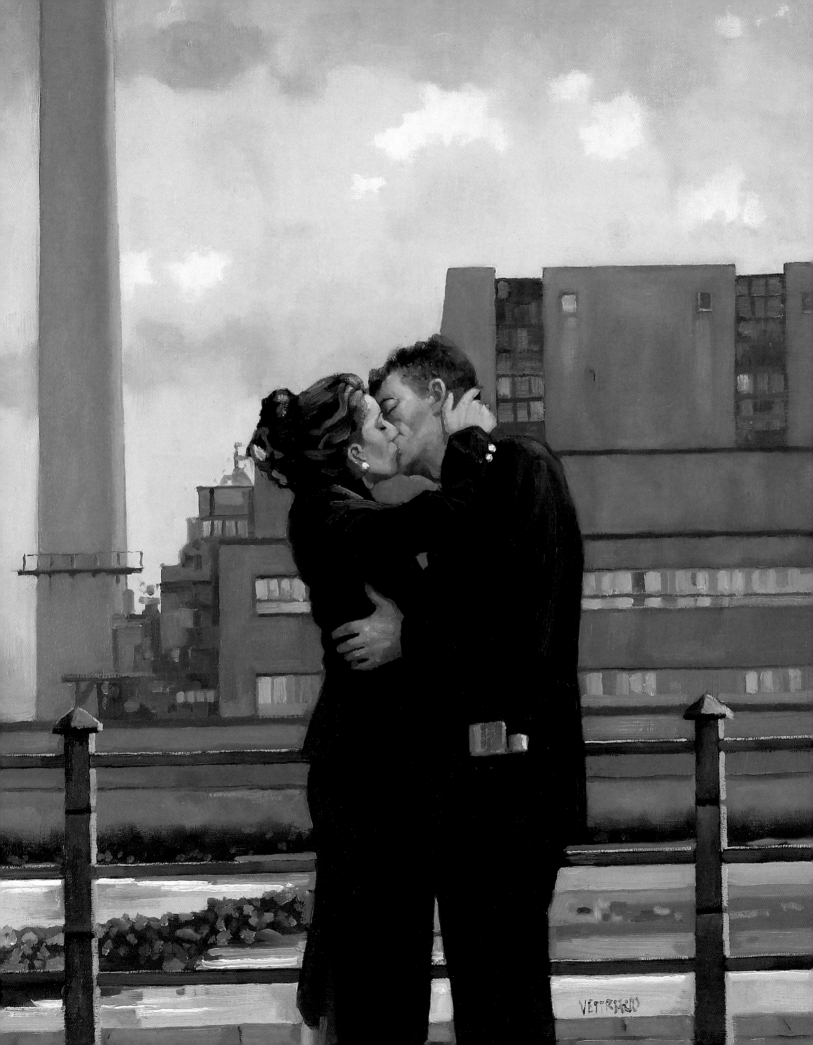

LONG TIME GONE

Jack and a model
in Nice.

Previous pages
Drawing room in
Kirkcaldy apartment.

middle-age madames and 'the sleaziness about the way some of the women dress'. He adds, 'They just really get it so wrong – I like it because it looks quite sexy'.

And yet, while the Cote d'Azur has come to influence Vettriano's more recent works, it's impossible to fully understand the narrative tension that lies at the heart of all of his paintings without first knowing his roots.

Born in 1951, Vettriano was the second of four children born to Bill and Catherine Hoggan. His father was a miner, as were both his grandfathers and virtually all the male inhabitants of the town of Methilhill. Home was a mid-terrace National Coal Board house in what is known in Scotland as a miner's row – each comprising two bedrooms, a sitting room, kitchen and bathroom. Not that the young Vettriano ever actually made it into the bathroom.

'My mother was a very proud woman. And the bathroom was reserved for visitors only. We all had to wash in the kitchen sink – something I only realised was unusual when I finally left home. To this day, my father shaves in the kitchen.'

While life was undoubtedly short on material comforts ('Another cup of water in the soup', was his father's cry whenever he learned his wife was pregnant again), these were happy times for Vettriano. Thanks to the mines, there was virtually full employment in the area, creating a sense of tight-knit community. The men worked while the women looked after the children and, for Vettriano at least, there was no burden of expectation stopping him from getting on and enjoying just being a kid.

'My parents never, ever had any aspirations for us – university was never even discussed. What was discussed was getting a trade, don't just be a miner, be a plumber, a joiner, whatever. So there was no pressure to do well academically, so I was out every night, playing with friends, no homework, nothing like that at all. It was just wonderfully free. I suppose it was a failing in a way, but because everything has turned out fine, it ceases to be one.'

At the age of ten, Vettriano and his family moved the short distance from Methilhill to Leven. Then a popular holiday destination, it would burst into life in the summer as day-trippers poured into the town. Vettriano watched and observed,

drinking in the atmosphere. The men were men – sharp-suited and smooth. As for the women: 'I think in those days women all wore stockings, and you could be guaranteed if you went out you would get a glimpse of a stocking top', he recalls, laughing. 'That did for me. I spent from the age of ten to about thirteen on my knees, desperate to catch a glimpse. Then there were the working girls who used to hang around the Innerleven Hotel. Me and a friend would wait around, looking at them all dressed up in that very cheap way. I believe that the things that move you when you go into puberty never quite leave you.'

Indeed, not only did his interest in the opposite sex start early, but to this day the specifics of that fascination resonate through his paintings – the big beehive hair, the red lipstick, the cigarettes, the sense of sexual tension. The men, too, owe much to Vettriano's teenage years.

'I saw these guys with their trendy clothes and I wanted to be like that. I wanted to hang around and smoke and look cool and get off with some of the local girls. I can remember specifically we used to play football in this area and a path went through it, where you went from a housing scheme down to the town, and these guys were walking through there. Everyone knew everyone, and I sidled up to one of them and said: "So where you going tonight then?" He replied that they were going to places like the Fan-Dan and the Purple Cat Club, and I remember going home and lying on my bed and thinking, "The Fan-Dan, the Fan-Dan – that must be some kind of place." I had this image of women lying about in their underwear. It was only much later that I found out that in fact the Fan-Dan was just a garage that this guy's parents let them sit around in and listen to a record player. But as a teenager, it was all so exciting.'

As he moved through his teenage years, Vettriano's dalliances with girls came thick and fast. He lost his virginity at the age of fifteen ('A total embarrassment and I won't say anything more than it happened in England') and would spend his nights scouring the dancehalls of Fife for willing women. 'It was all about what we called "the dancing" then. There was the Raith and the Burma, these Art Deco ballrooms with live bands. They'd play three fast songs and three slow ones

LEGS ELEVEN

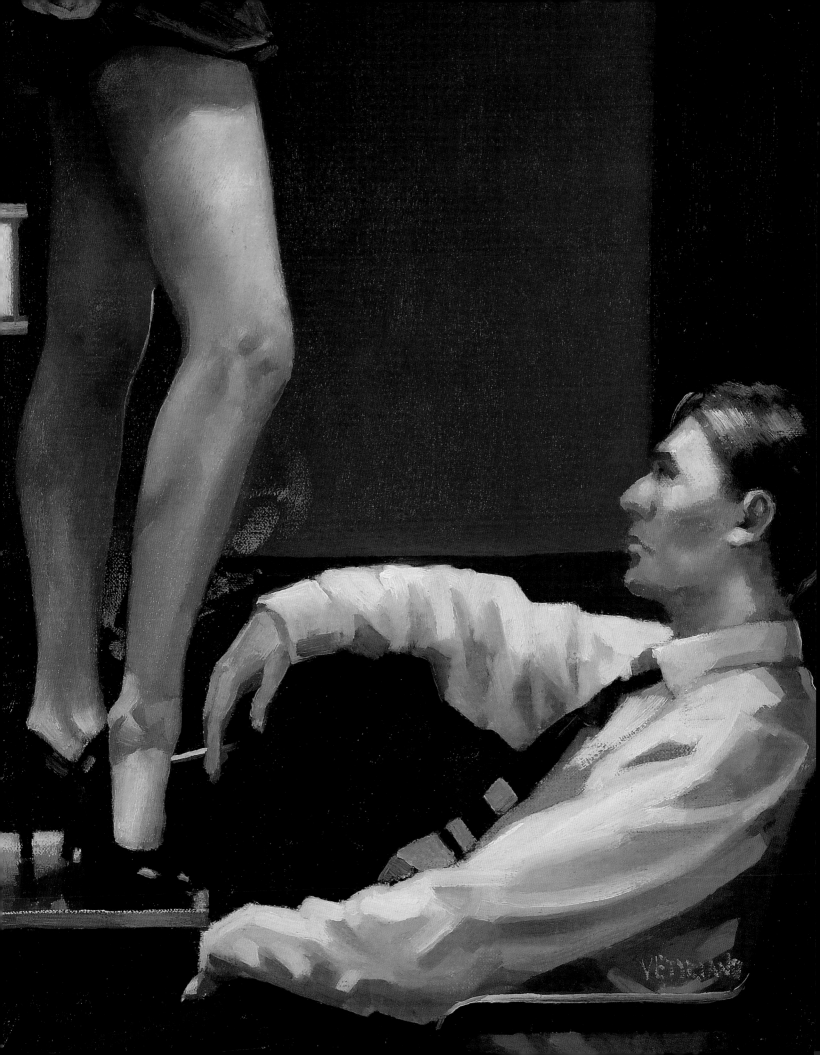

all night long, so you had hours in which to pull. My friends and I would watch from the balcony, then it'd be, "Let's go for those two" and off we'd go. At the end of the evening, there was a sort of ritual, where the girls who had been "pulled" would be sent off to go and get their coats before leaving. If they were pretty, you'd arrange to meet them where all your mates could see them, to show off a bit. If they weren't, you'd usher her out a bit more discreetly, without a fuss. I don't think I ever left the Raith without picking someone up. It was that kind of world.'

And it is a world the detail and atmosphere of which would later come to feature in many of his paintings – the Art Deco balconies, the suits, the high heels. Equally significant to Vettriano were the

beaches of Leven, again the backdrop for many of his most famous works.

'During the summer, the whole game of picking up girls was played out during the day as well. There was bingo, the fairground, the promenade. I don't know how many summers I spent by the Waltzers, looking at the girls. The game was being played around the clock. You know the game of

life and love is played out on beaches because that's where you go when you fall in love. It is a place where courtship takes place, and I can tell you I 'courted' a few girls on the beach.'

They were happy days, and ones Vettriano might have been tempted to dwell in forever were it not for a nagging itch that he should really be doing more with his life.

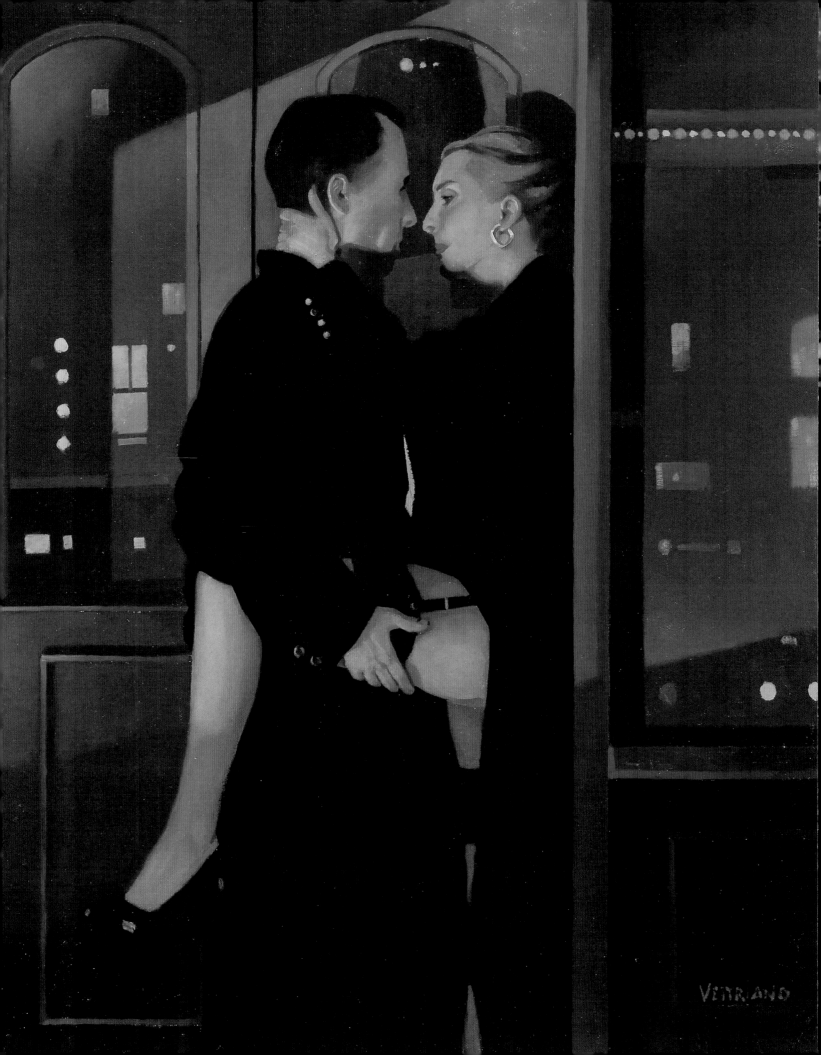

SOHO NIGHTS

Having left school at the age of fifteen with no qualifications, he got an apprenticeship with the Coal Board as a mechanical engineer. It was considered a good trade, but Vettriano hated it: 'I worked very hard at trying to do very little, and I have to confess I was very good at it'. Four years on, at the age of nineteen, he had completed his apprenticeship but did not take up the post of mining engineer. Instead, over the following two years he would have six different jobs – starting with a position as a door-to-door salesman.

'There was this advert in the paper that said they were looking for people to conduct "interviews". I thought I'd end up famous, like the next Michael Parkinson, but instead I ended up in Darlington pounding up and down the streets'.

Quickly tiring of that line of work he moved to London, convinced the pavements there would be paved with gold. He lasted just three months, surviving on low pay and iron rations in a series of dead-end jobs that he endured for as long as he did only to delay the embarrassment of returning to Scotland empty-handed.

Back home, Vettriano met a woman, a schoolteacher. He dated her and she gave him a set of poster paints and encouraged him to dream, to once again set his horizons beyond Leven.

'I was twenty-two and I realised I couldn't carry on living the life of a Jack the Lad for ever, that I'd get someone pregnant. I stopped listening to Motown and started listening to Bob Dylan and thinking more about the future. I took night classes to get some exams, and then there was the painting. I can remember my friends being highly amused at me not going out during the week because I was painting. And when you can't paint, you try to look like you can and I went the whole way – beret, smock and palette'.

But for the best part of the next two decades, painting would be nothing more than a hobby for Vettriano. He practised copying other artists, starting with the Impressionists and them moving on to the likes of Picasso and Dali. During that time, he moved between a number of white-collar jobs and married Gail Cormack, a local girl from Kirkcaldy. But while he gradually climbed the property ladder and into the middle classes, Vettriano grew disillusioned with his lifestyle. Again there was that nagging itch that he could be doing something more.

MOTEL LOVE

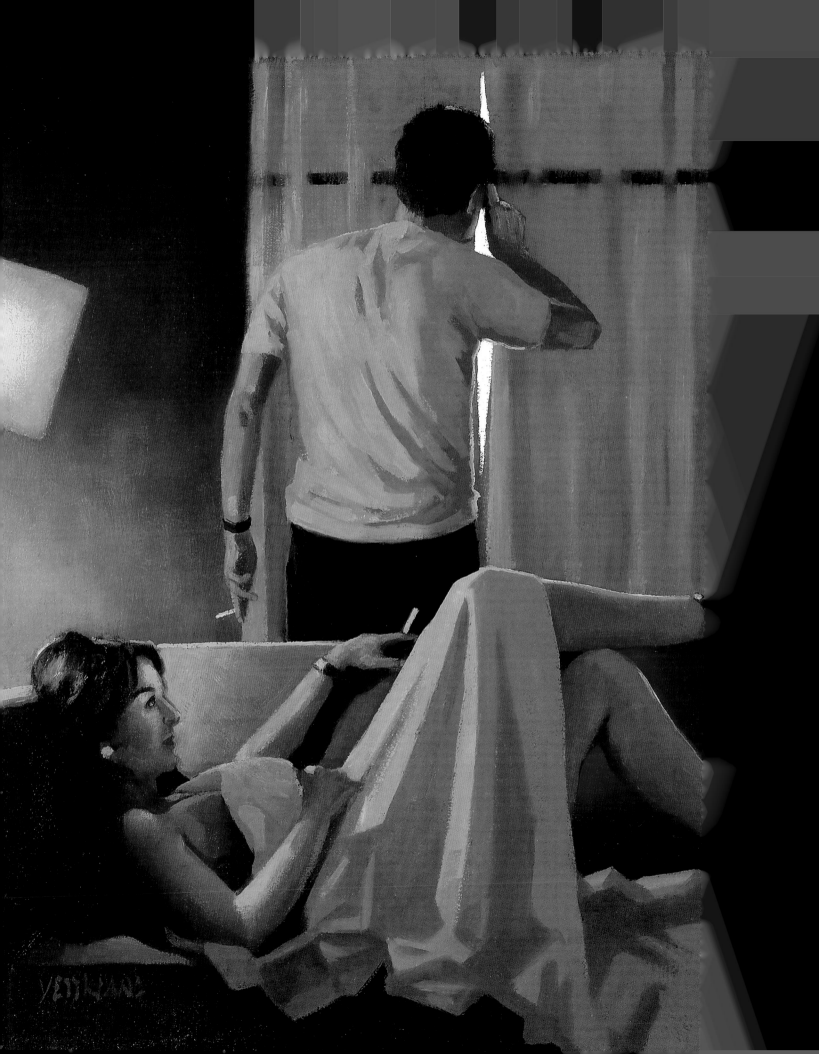

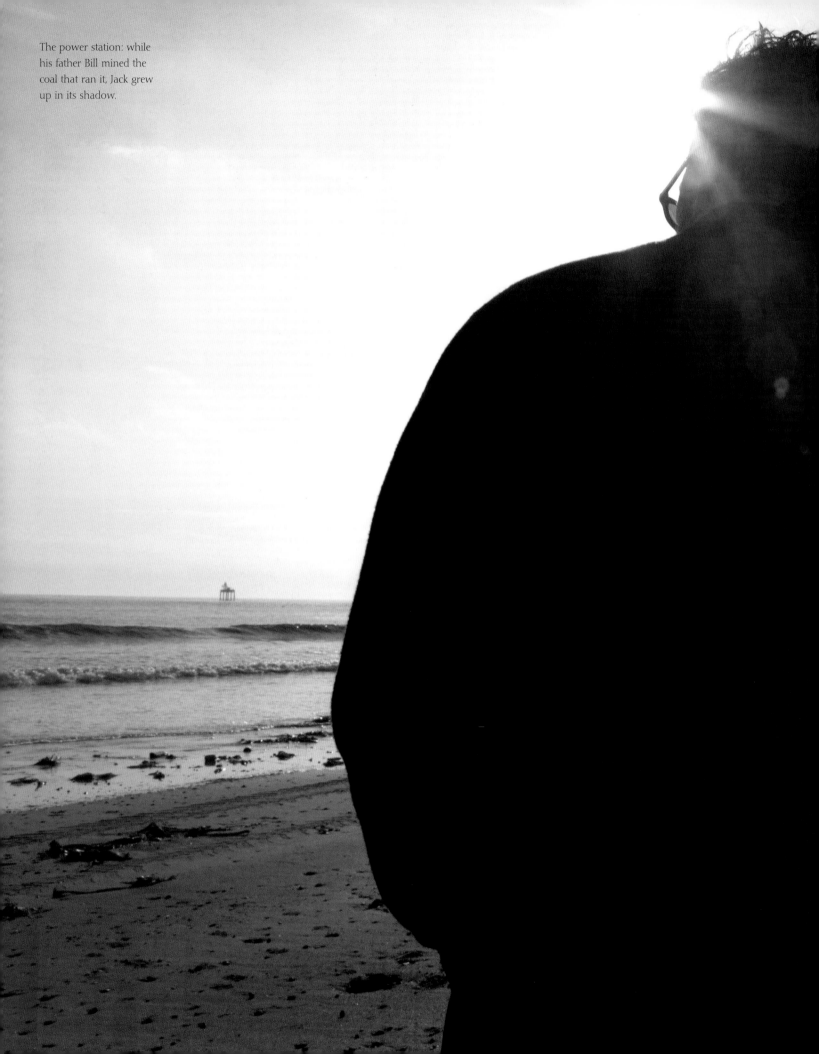

The power station: while his father Bill mined the coal that ran it, Jack grew up in its shadow.

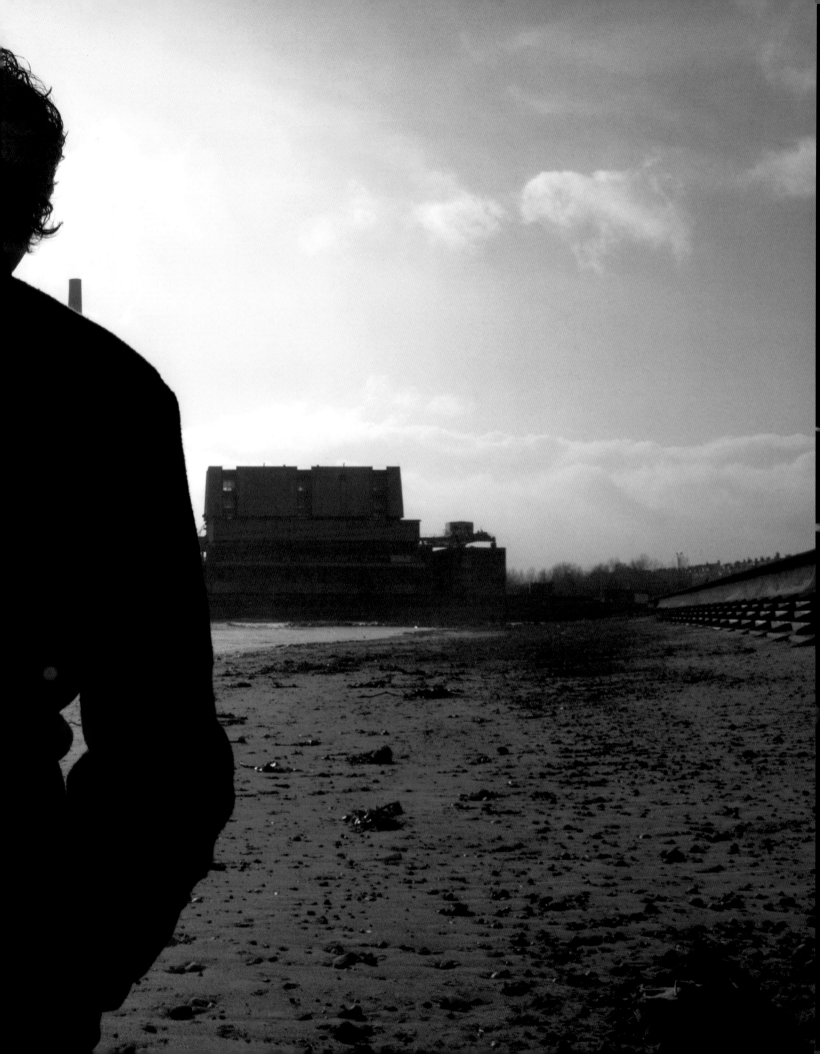

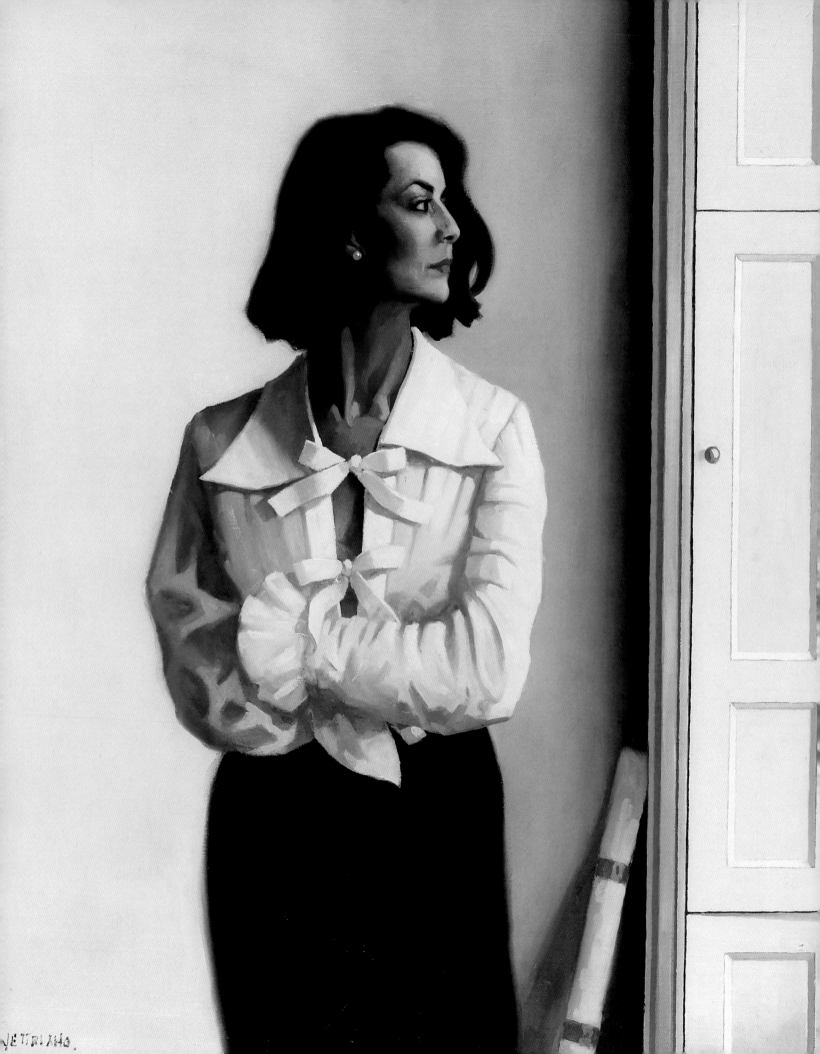

EDINBURGH AFTERNOON

He started to devote all his spare time to his painting and grew desperate for his talent to be recognized by his peers. But he knew it was no good turning out copy after copy and that he needed some original subject matter. And so it was that in 1988 Vettriano submitted two small paintings to the Royal Scottish Academy's summer exhibition in Edinburgh.

'One was of a guy standing against an Art Deco pillar called *Saturday Night*. It was just a wee memory of a corner of the Raith ballroom. The other was called *Model in a White Slip* – it was a painting of a woman in a white slip'.

Both paintings sold within minutes of the doors opening, and Vettriano was hooked. 'I remember going back home on the train that evening and thinking: "If you like that kind of work, I've got plenty more where that came from." The memories started flooding back. My subject matter had been sitting right in front of me all the time, but what had been holding me back was I never thought anyone would be interested in it'.

Vettriano started painting for sixteen hours a day. He withdrew into his work, stopped socialising and his marriage collapsed. In 1990, he moved to Edinburgh and threw himself into his new life as an artist. His paintings drew heavily on those early recollections but, equally, there were new influences as well.

'With my marriage having broken up, I was very interested in the dynamics of relationships – the way people cheat and lie and twist things. Lots of my paintings then started to examine emotions such as betrayal and jealousy'.

Vettriano refers to his time in Edinburgh, eight years of it, as being particularly 'hedonistic'. By that, he means that he regularly visited sauna parlours and prostitutes.

'I was using them because I wanted to see what that world was like and at the time I loved it. In retrospect, maybe I should not have gone as far as I did. The problem is that certain people in that world have one agenda and one agenda only – and that is making money. Inevitably it means other people are getting used'.

Again, this time in Edinburgh provided a rich vein of inspiration for Vettriano, who turned the interior of his house in Lynedoch Place, an elegant Georgian terrace, into a virtual stage set for his paintings. Fun for a while, this life as the bohemian dilettante also had its drawbacks. Vettriano, with his long hair, braces and old-fashioned suits, started to attract the attention he had craved. But once he had it, he realised there were aspects of it he didn't much like.

'Edinburgh is just a village, and I became relatively well-known quite quickly. I started to feel increasingly uncomfortable socially and, looking back, I had also attracted a few hangers-on.' (His painting *Feeding Frenzy*, in which a woman's kiss turns into a bite, was inspired by the sense that certain people were 'using' him.)

In 1994, he had his first exhibition with the Portland Gallery in London. Regular exhibitions with the Portland meant that Vettriano started to spend more and more time in London. In 1998, he headed south once more for the opening of his show – and stayed, buying himself an apartment close to Harrods.

Left Detail from Jack's London studio.

Right Jack takes in the view from his studio balcony.

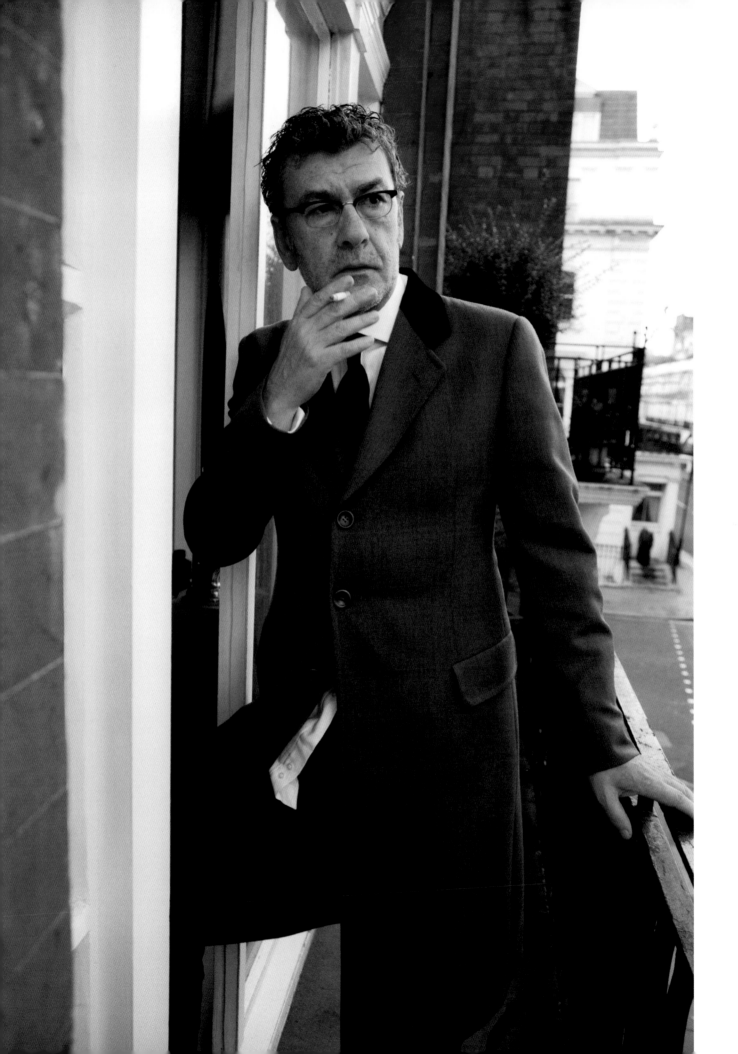

JEALOUS HEART

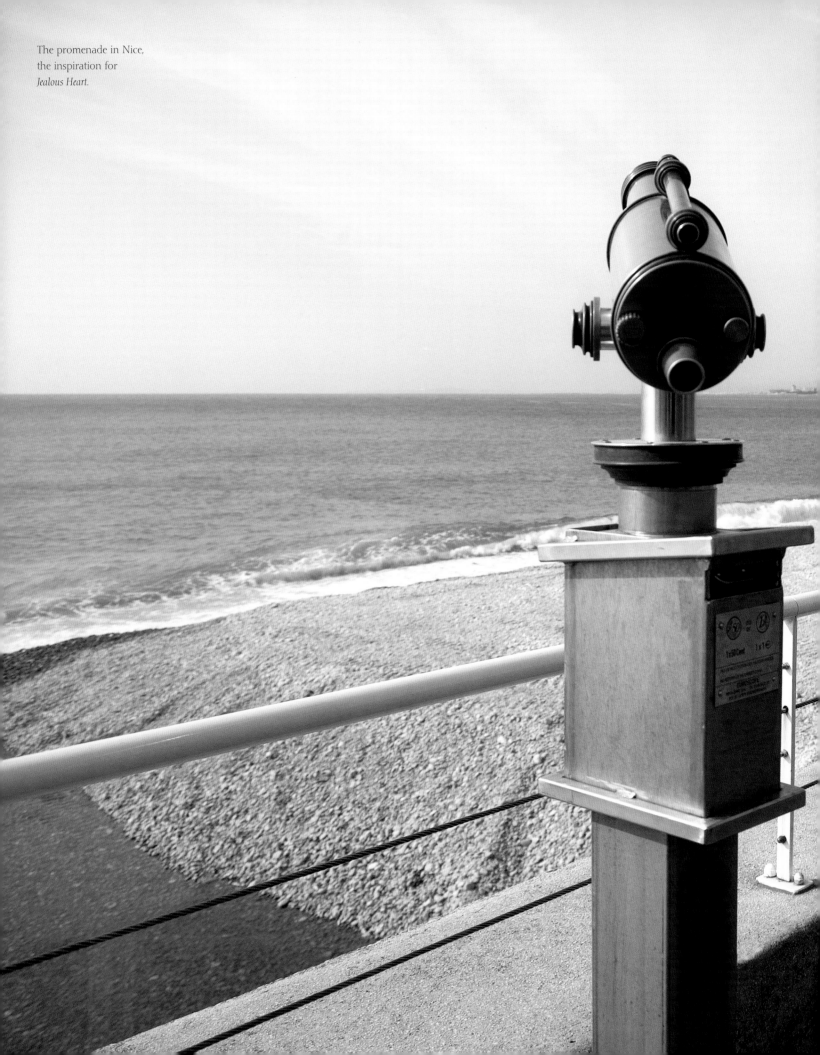

The promenade in Nice,
the inspiration for
Jealous Heart.

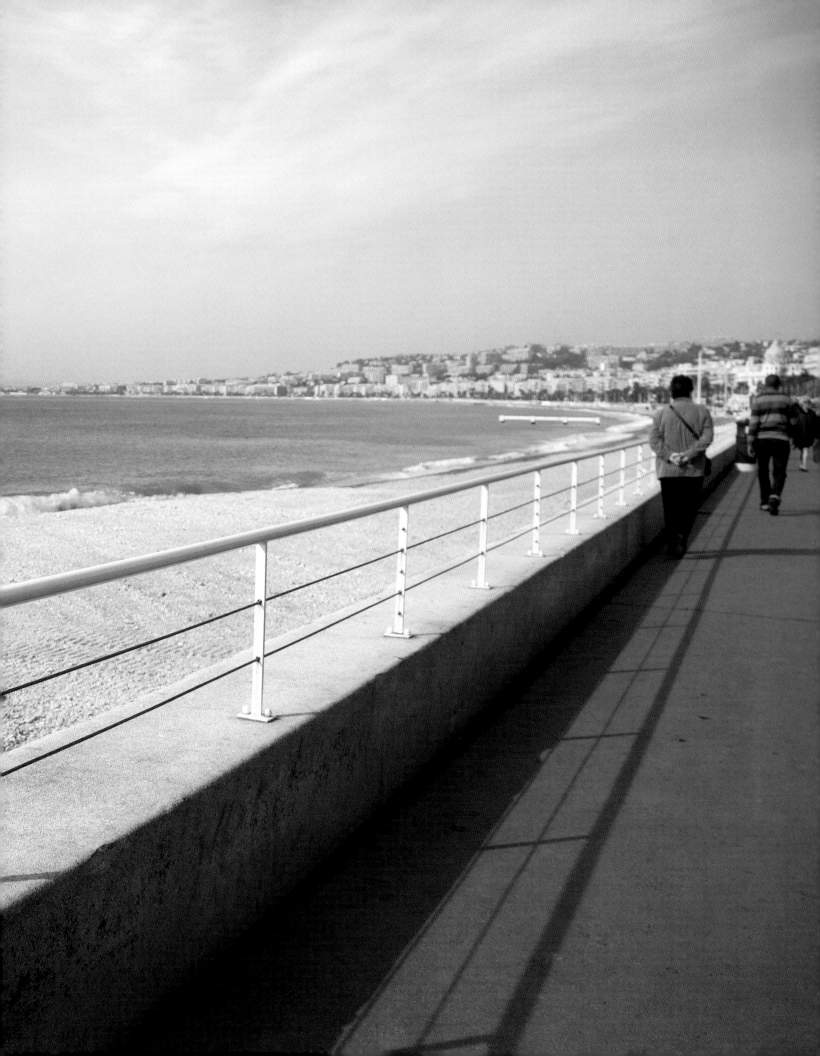

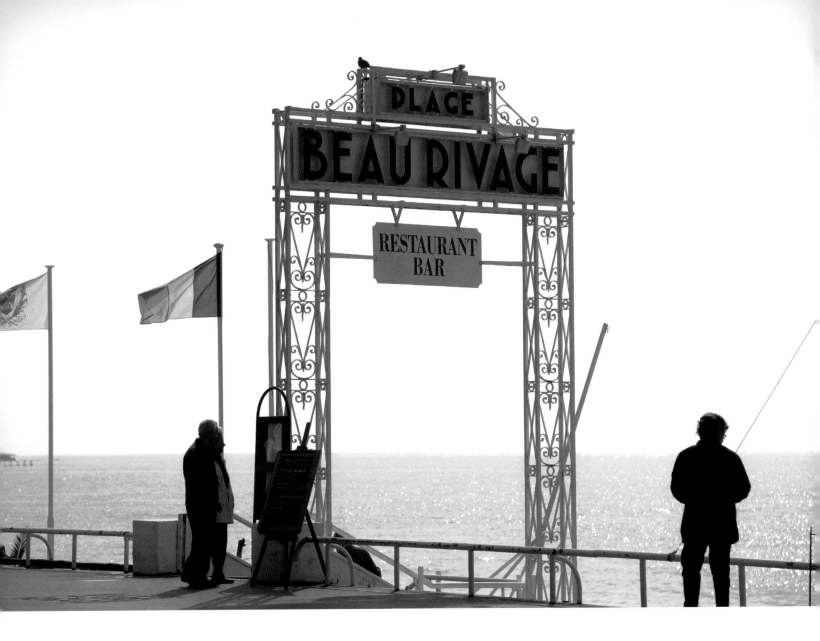

He loved the relative anonymity of the capital, which meant that he could once again walk the streets unrecognised, something that had become impossible in Edinburgh. And he also loved the stimulation, the visual pleasures that surrounded him. The area in which he chose to live is one of London's most affluent – full of lunching ladies walking their dogs and Mayfair playboys pointing their Porsches in the direction of their next rendezvous. For while Vettriano is instinctively drawn to the seedier side of society, there is no doubt that he draws comfort from his immediate surroundings being beautiful, ordered, reassuringly exclusive. These contrasting requirements are perfectly met by his apartment in Nice, which he purchased while on holiday in the south of France in 2004. Of course, Vettriano could have afforded to live in Cannes or St Tropez, but that's not his style. He likes the unpolished edginess of his place in the sun – the crooks and the prostitutes and the feeling that anything could happen.

Above, and above right
The flags, the signs, the beach – elements of the south of France that have been assimilated into Jack's work.

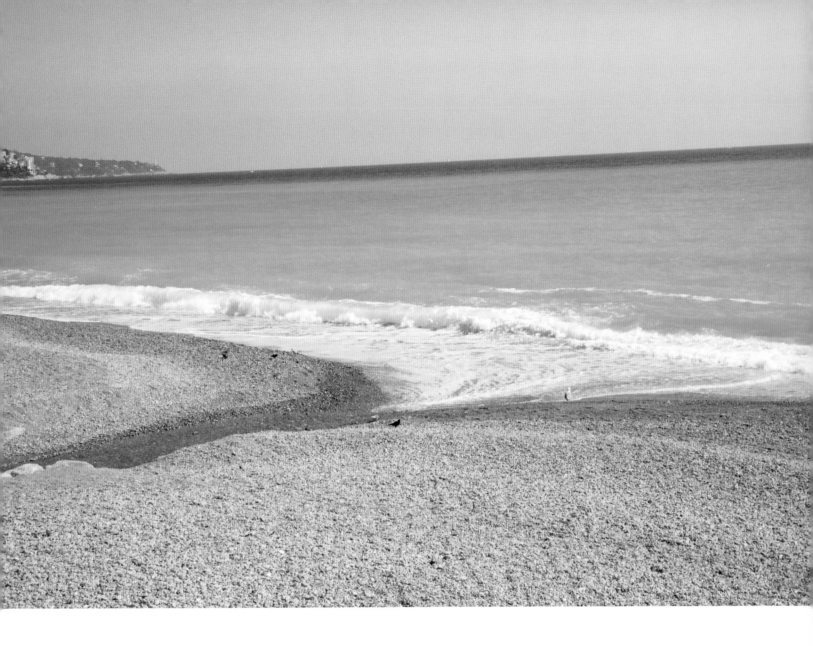

Following pages
Jack outside his favourite
casino in Nice: 'I love the
atmosphere when
someone playing for big
stakes comes in.'

'Nice has a certain sleaze to it. It is not full of beautiful people. There are a lot of crooks there, a lot of prostitutes there. A girl I know put her finger on it. She said: "In Nice, there is actually a level below trailer trash."'

As well as the sensory stimulation (wherever he is, he mentally records details that he sees: an ornate lamppost in London, a carved doorway in Nice), the bottom line is that Vettriano enjoys his lifestyle in the south of France.

When he is working, a typical day begins early,

when Vettriano will block in a canvas and then head off to the beach for a swim. By the time he returns, the paint will have dried sufficiently for him to start work. Leisure activities include the occasional gentle jog along the promenade and restaurant meals of salad and seafood. For entertainment, there is the local casino. He goes there two or three times a week and always plays roulette, a game of chance that allows him to think and to observe. 'I love the atmosphere when someone playing for big stakes comes in. The buzz and the tension are incredible.'

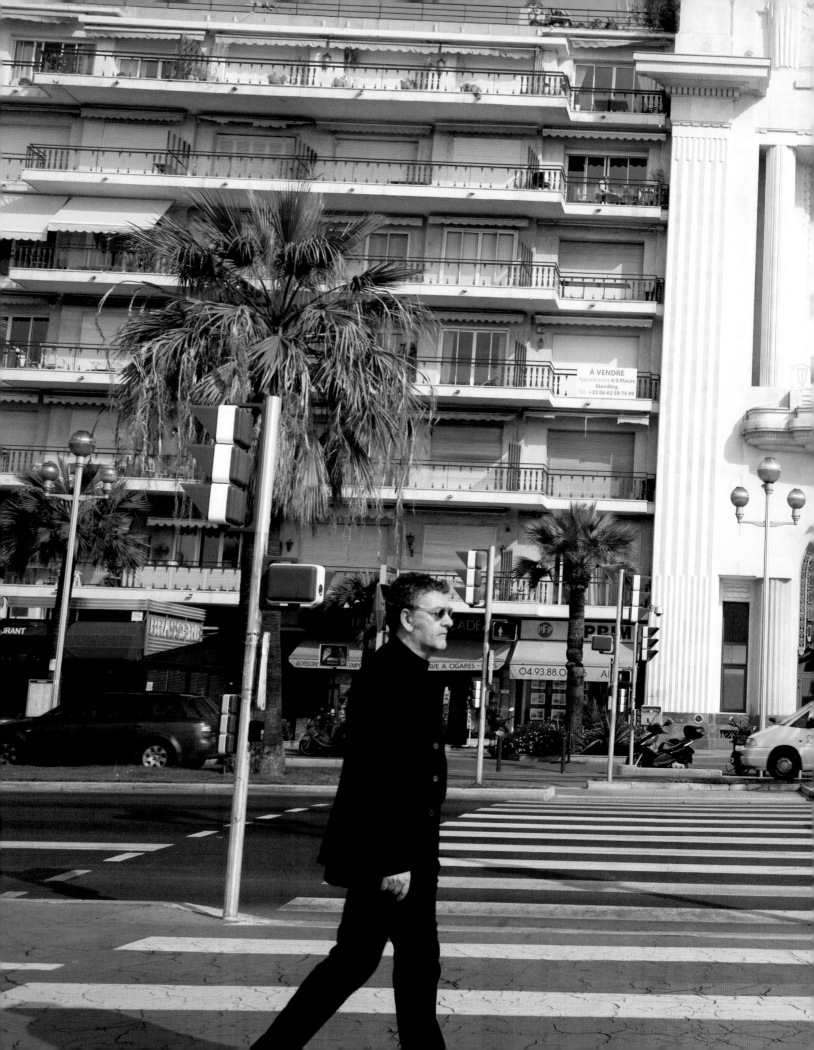

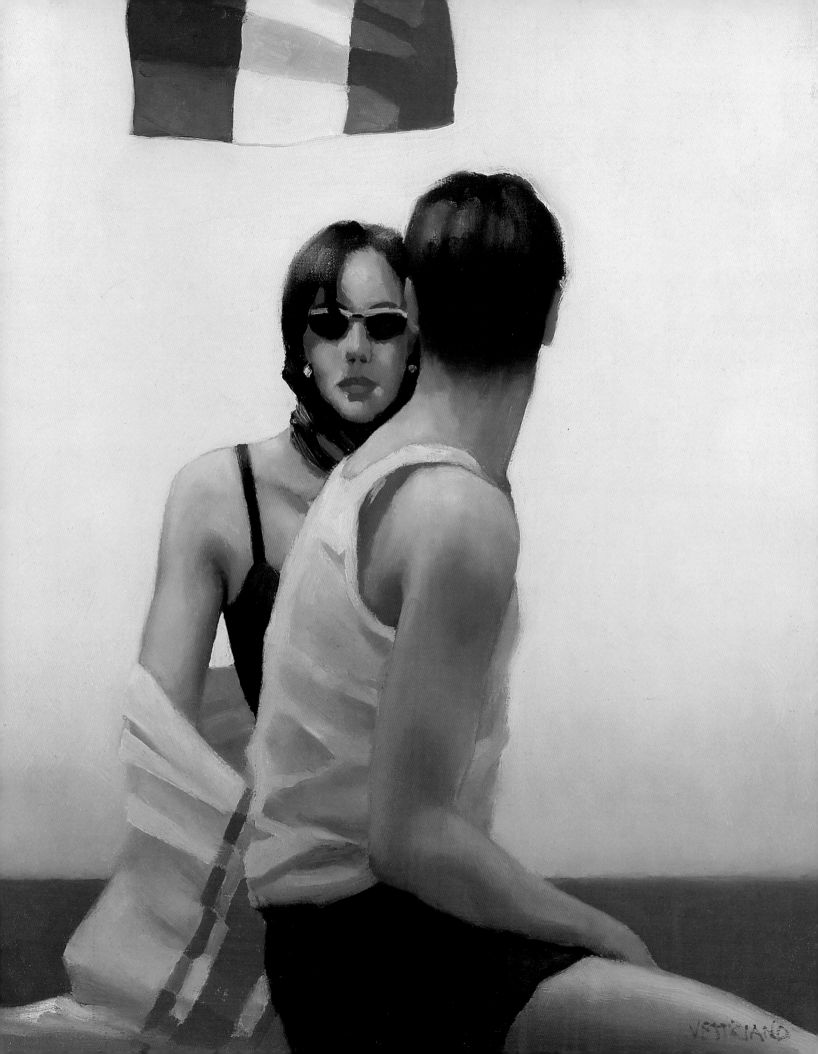

RIVIERA RETRO

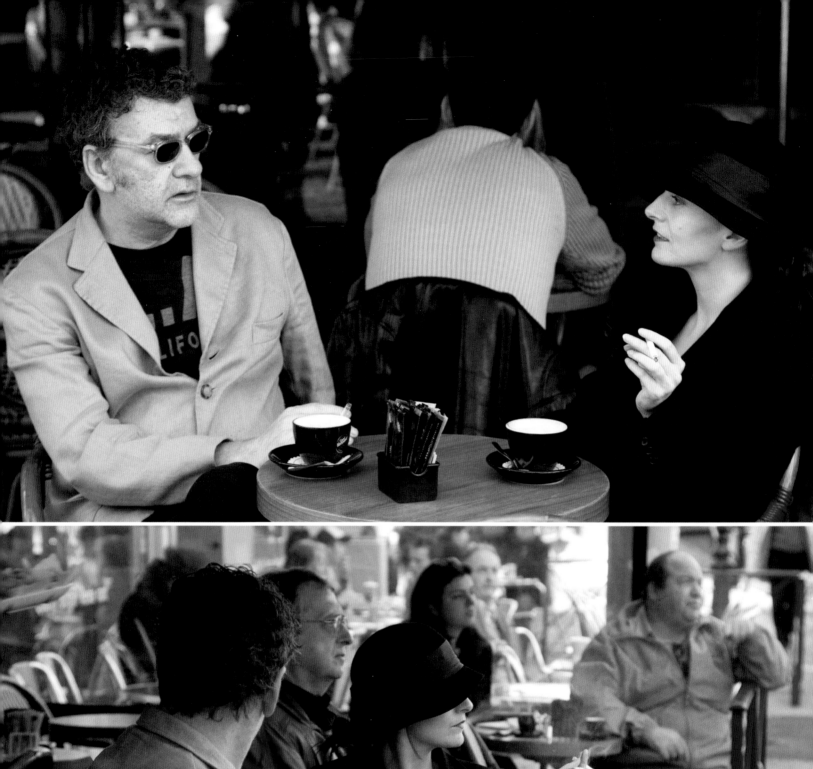
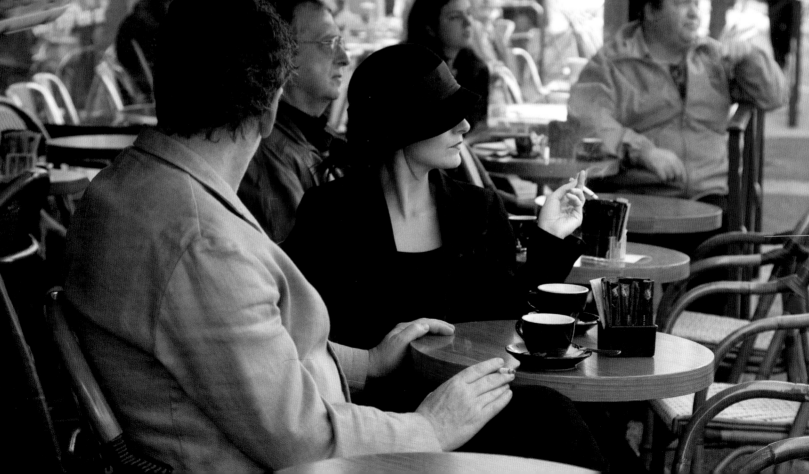

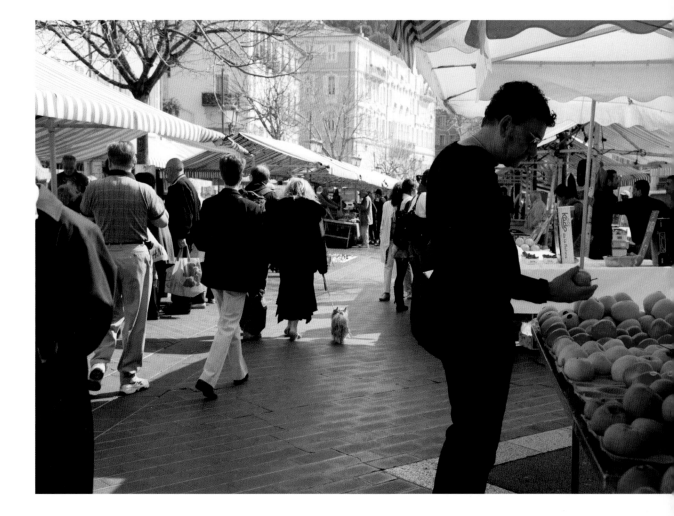

Nice: *al fresco* eating, the
markets and the feel of
the sun on his back.

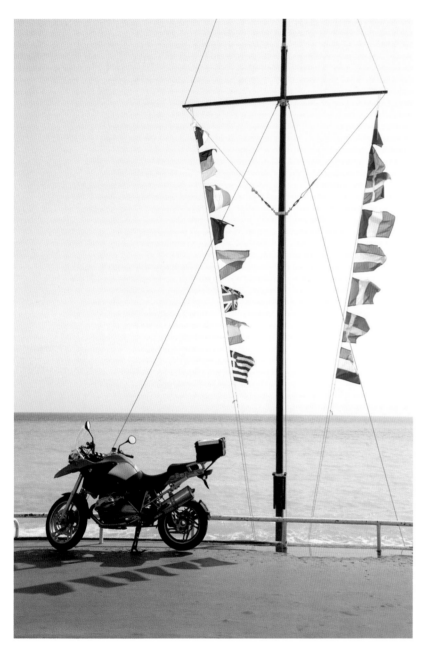

Inspirational Nice.

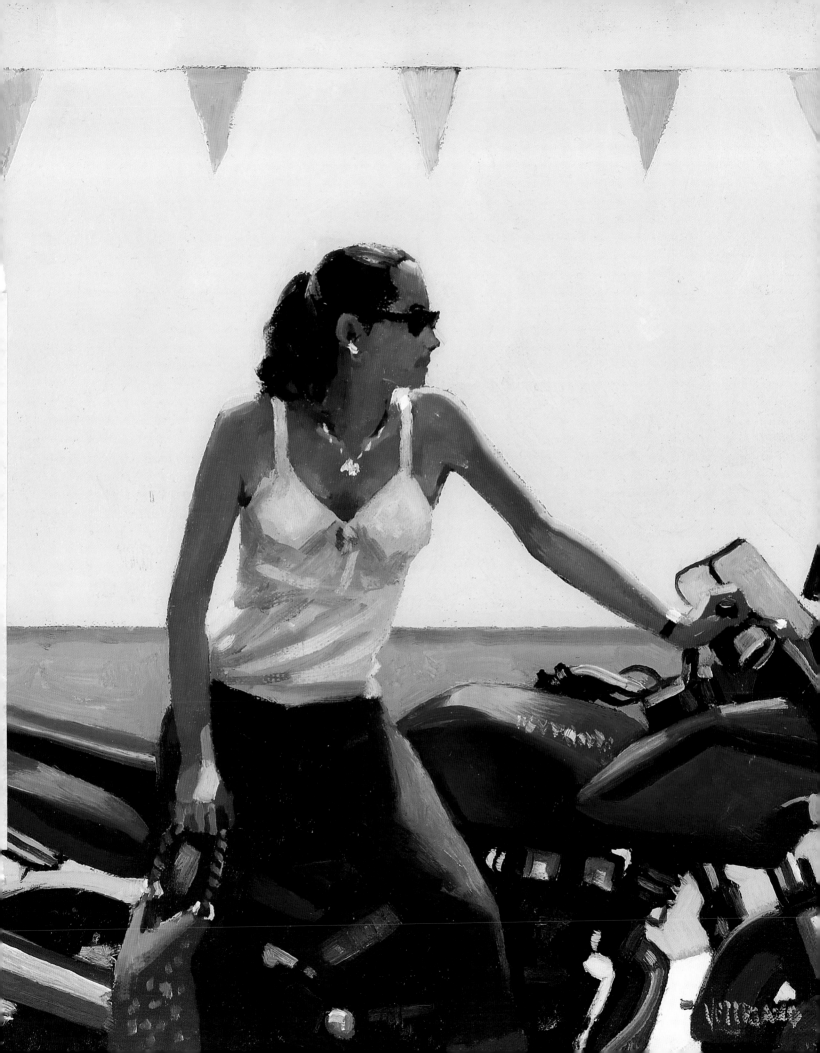

HER SECRET LIFE

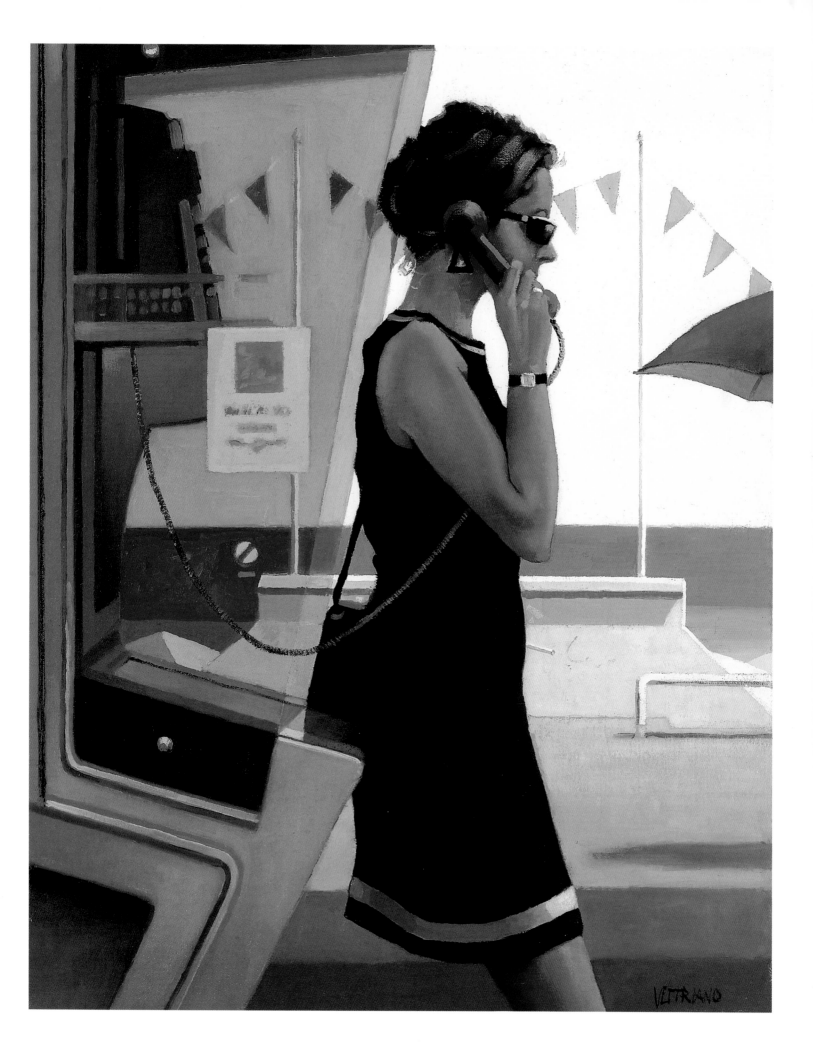

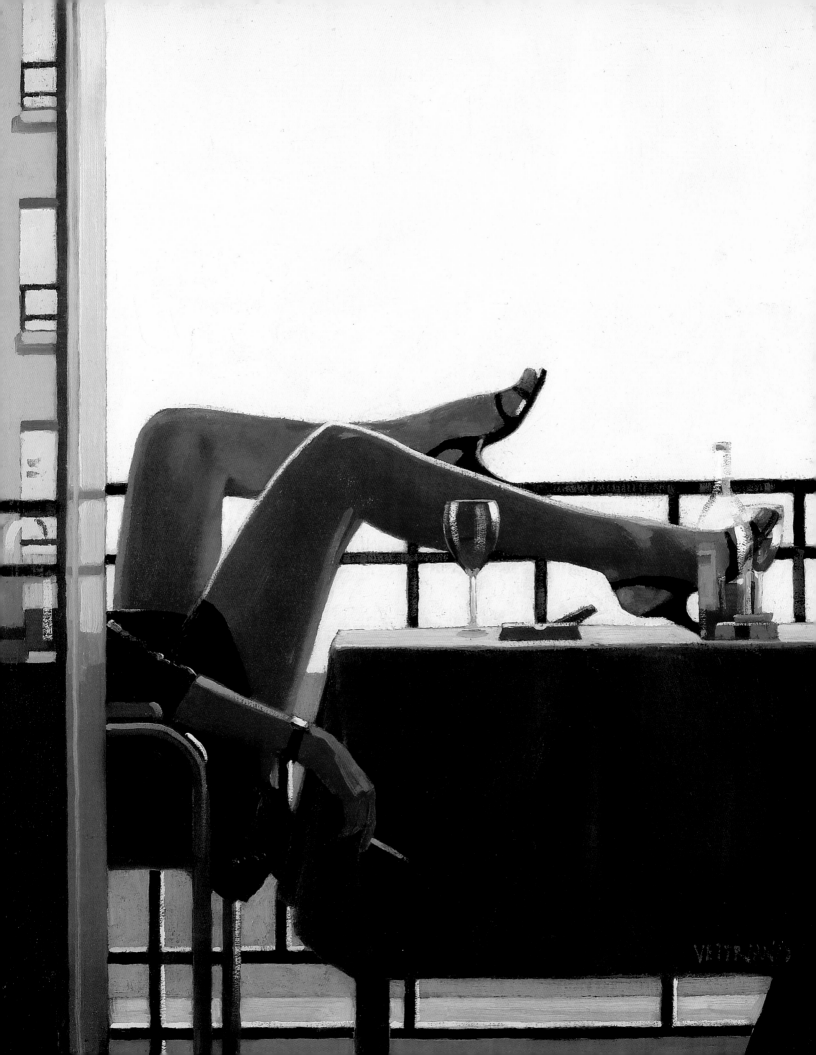

THE TEMPTRESS

EXIT EDEN

Left
The original inspiration
for *Exit Eden*, taken by
Jack on his mobile phone.

Book ends and a sofa in
Jack's apartment in Nice.

PSYCH

ALONG CAME A SPIDER

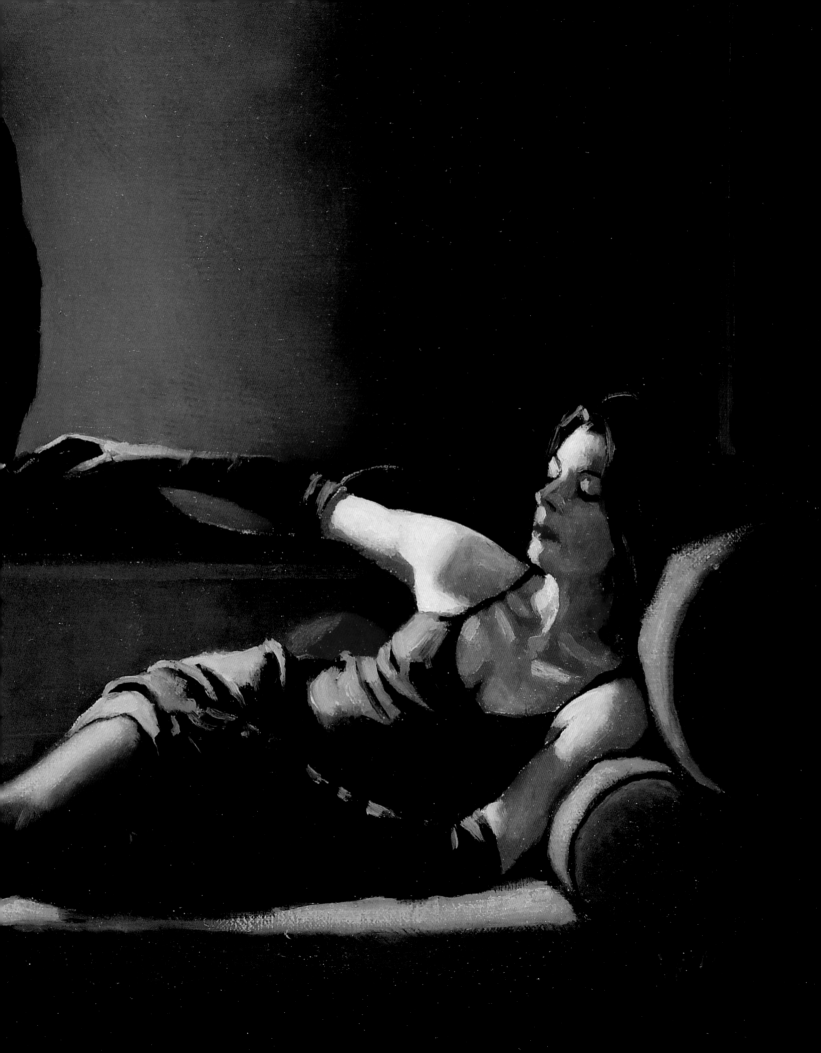

The influences of the south of France are clear in many of his latest paintings, providing backdrops for works such as *Exit Eden* and *Riviera Retro*, but as ever with Vettriano, it is the people who are everything. It is of interest to note, then, that his latest muse Maggie, who appears in a number of his most recent works, hails from Fife. Jack's friendship with Maggie was forged over a number of years through her work as a journalist – a sign, perhaps, that while he may spend only a month a year in Scotland, his Scottishness will never truly leave him.

And while Maggie may most recently have posed on the promenade in Nice for the paintings *Her Secret Life* and *Blades*, it's significant that she also appears in *Long Time Gone*, an evocative study of a couple kissing in front of Methil Power Station.

'The power station is going to be knocked down and I wanted to paint it because I wanted some memory of it. And, at the same time, the idea of being a long time gone is significant to both Maggie and I. I'm very indebted to this part of the world because it was what formed the man and gave me such a reservoir of material to draw from.

My painting may now be much more personal to me, but the memories still keep me going, the adventures of days gone by.'

Today, his trips back to Leven are confined to a stroll down the beach and time spent with his parents, who still live there. They are supremely proud of all of his achievements – as, indeed, is the community as a whole.

'There is a street named after me in Leven,' Vettriano says, amused. 'When the council said they wanted to do it part of me thought, "Great! Jack Street, that's got a wee bit of an edge to it." So what did they call it? Vettriano Vale! My embarrassment was in equal proportion to my parents' pride. I cringed my way through a photo session organised by a local paper – my parents beaming with pride, me wincing with embarrassment as I cut the ribbon on the opening day.'

And so, just as Leven and Methilhill will always have a special place in Vettriano's heart, so too will a small corner of Fife forever be linked with the painter.

All roads, as Jack himself has observed, really do lead back to the place of his birth.

From the Cote d'Azur to the beach at Leven, Jack returns 'home' regularly to visit his parents.

PART THREE

CULTURAL INFLUENCES

SIMON NAPIER-BELL

BLACK VINYL

A STUDY OF HIS ETCHINGS BY RIC

WHITE POWDER

LEDGER

CADELL · A SCOTTISH COLOURIST

Tom Hewlett

BETTY PAGE - QUEEN OF PIN-UP

THE SCOTTISH NATION

VOL. I.
GE. - CUR.

THE SCOTTISH NATION

VOL. III.
MAC. - ZET.

THE SCOTTISH HIGHLANDS

VOL. II.

FOREIGN

M ost people listen to music to give them a lift, to raise their spirits, to gladden their heart. Not Jack Vettriano. The opposite, in fact.

He works best when there's some friction in his life, when things aren't going as well as they might. And when he's down, he'll flick through his album collection, looking for some Joni Mitchell, some Leonard Cohen, some Bob Dylan. Wrapped in his thoughts, he'll sit and think, listening to lyrics he's listened to a hundred times before, cocooned in melancholia.

'Over the years it's true to say that I've acquired an ability to ensure things don't become too easy for me,' admits Vettriano. 'I remember once in Edinburgh meeting a girl who I really, really liked. The studio I had then overlooked the castle, and I spent hour after hour looking at it and thinking, "God, isn't life great!" At the end of the day, I sort of came to, shook myself back to consciousness and gave myself a bit of a talking to: "This won't do, you can't bloody work, sitting there thinking about a girl, you're way too bloody happy." So I ended it, and I've found that for me to paint I need this slightly destructive streak, need to be able to destroy the things that are good for me.

And when I've done it, I'll go and listen to some sad songs just to compound it all. It doesn't pick me up – the opposite, in fact – but there is inspiration in it for me.'

Flick through Vettriano's catalogue of work, and it's clear that of all the cultural influences upon his paintings, music is by far the most important.

Intriguingly, it's not so much the narrative thread of a Dylan classic or Mitchell track that inspires him so much as a single line or, indeed, even a fragment of a line. For as his paintings depict a freeze-frame moment in an unspecified story, so too can a few words open a door for his imagination.

'I love playing around with lyrics and I love what they do to me and for me, and there are plenty of examples in my work of how they have inspired me. For example, there's "Dance Me To The End Of Love", a Cohen song. When I heard it, read the title, I just thought "Now what does that mean pictorially?" You can say it and you can sing it, but you don't have a vision of it. I tried to give it vision and, interestingly, when I first did that painting I had the couples dancing across the canvas from left to right, but I knew instinctively

Previous pages
Jack's bookshelves in the London studio.

DANCE ME TO THE END OF LOVE

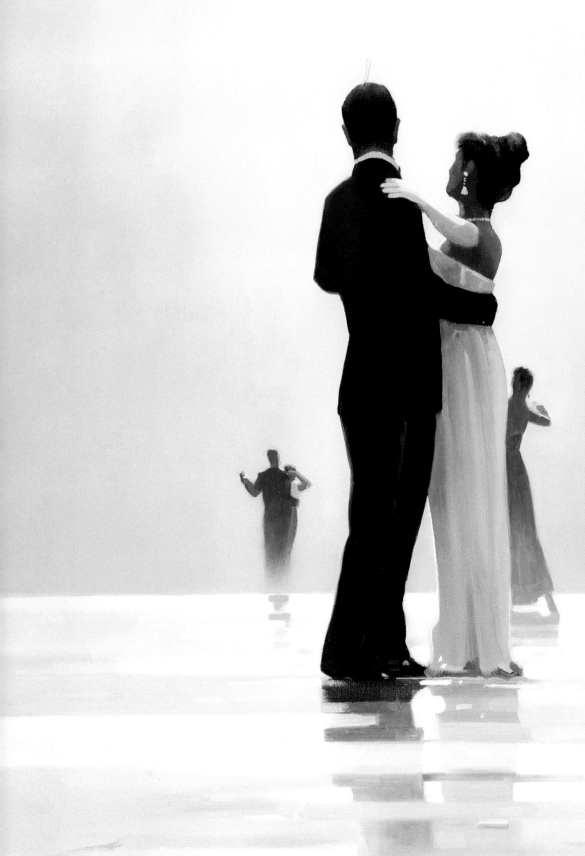

In the London studio.

that was not what I wanted, that it didn't describe dancing to the end of love. So I changed it and had them dancing away from each other into the distance, as though they really are dancing around the world to the end of love'.

Back to his CD collection and next up is the Joni Mitchell song 'Shades of Scarlet Conquering'. 'The track is about a brittle Southern woman who is ice cold, who is like Scarlett O'Hara. I listened to it over and over and thought to myself how I quite like women who are dominant, hard women. I wanted to capture that sense of toughness, to put [it] into a painting. I used my house in Scotland as the backdrop: it had scarlet walls, and had the

woman standing on my staircase looking down with an expression of total disdain at a man gazing expectantly at her'.

Then there's 'Heartbreak Hotel' ('a slightly sleazy place where you don't go for comfort, you don't go there because it's got a nice cocktail bar, you go because you want to be alone') and 'Bird on the Wire' ('the woman looks like a little sparrow sitting alone, waiting for the hawks to come').

The paintings are about longing, lust and love – and like the songs that inspired them, there's always an edge and an element of the broken, of the imperfect.

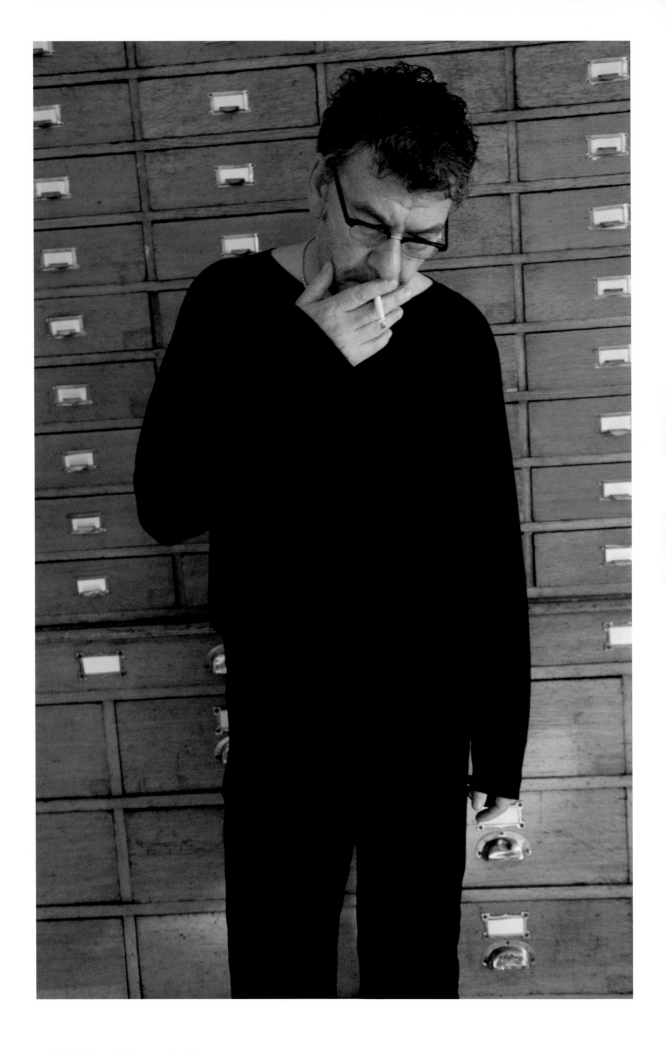

'I always seem to paint better when I am feeling some kind of pain or am emotionally handicapped'.

It goes to the heart of Vettriano the artist and the man, this obsession with the unsettled and the unsatisfied. And as he himself is prepared to admit, it's something that he actively seeks out and encourages in his own life. Indeed, ask any friend of Vettriano to describe his character, and all will say his life is very much marked by highs and lows. And that just occasionally those lows can become a little bit too low.

'I always seem to paint better when I am feeling some kind of pain or am emotionally handicapped. I suppose that is both a bad thing and a good thing because it does make you very pensive, thoughtful. But, of course, there's a downside. You don't go out, you don't want to socialise and

you can just get a wee bit too down and it can lead into a sort of depression.'

Do people become artists because they are troubled, or does it happen the other way around? In Vettriano's case, two very distinct phases to his life can be distinguished: pre-melancholia and melancholia. Both have been marked, even defined, by very different approaches to music.

'When I was growing up in Fife, it was all about the dancing, the girls, the going out and having fun. Tamala Motown was huge then and I loved it. It was one great record after another – it was the Four Tops, The Temptations, Diana Ross. The bands at the dancehalls would cover whatever was in the charts. All I cared about was whether it had a good rhythm and whether I could get a girl dancing to it.'

But by the age of twenty, those frivolities were set to become a thing of the past. Having spent four years completing an apprenticeship as a mining engineer, Vettriano decided to seek his fortune in London.

'I went there very naïve and was only there for three months as a trainee chef, living in a mouse-ridden flea-pit in Camden Town, but it did waken

Left Nice studio: Antique light with daylight bulbs.

Right Paintings in the drawing room in Kirkcaldy.

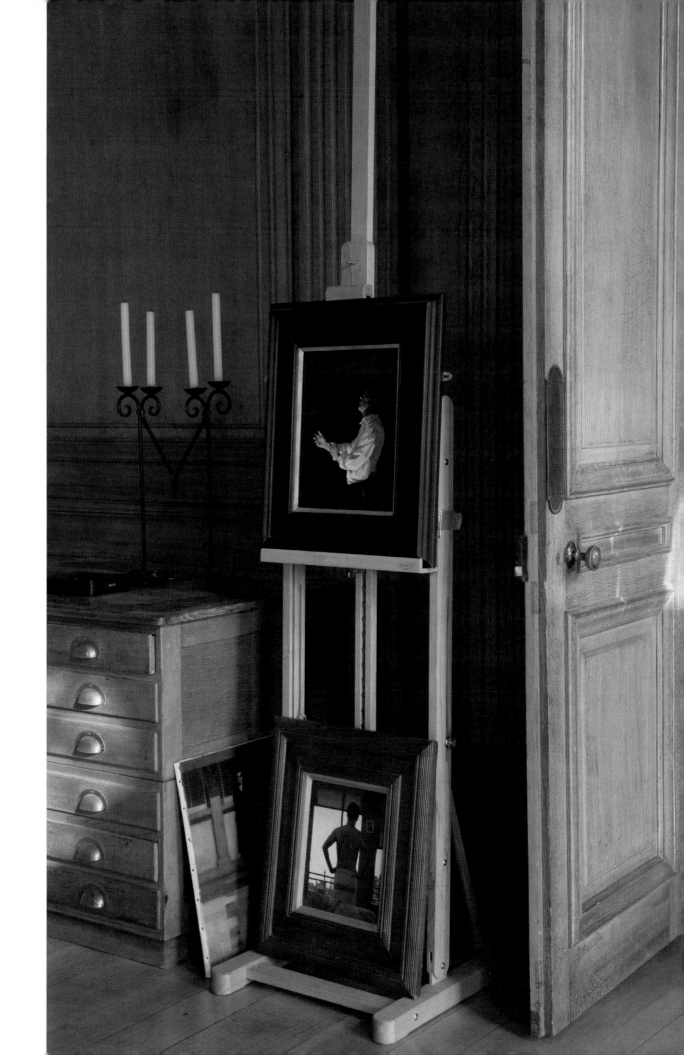

me to the wider world. Nowadays there is so much information everywhere – in magazines, on the internet – that people's worlds are so much bigger than they used to be. Back then, the only way you learned about other people was going on to university and meeting different people from different backgrounds, and I never had that opportunity. It meant that coming to London was a real eye-opener, and I started to think a lot more about my life. That's when I started listening to Dylan, to Crosby, Stills, Nash and Young. To me, they were the first people who were writing about life and not a lot of nonsense. Don't get me wrong, The Beatles were great to listen to, but their early music wasn't meaningful, not like Neil Young and Dylan. I remember listening to "Like A Rolling Stone" for the first time and it just blew my mind. That someone would describe a car as a "chrome horse" was incredible to me. In every line, there was a painting. It really struck a chord, and even now I can listen to Dylan constantly in a way I can't to anything else. Don't forget that my background was so uncultural that when I actually surrendered to this sort of music it really knocked me out.'

LUCKY 7

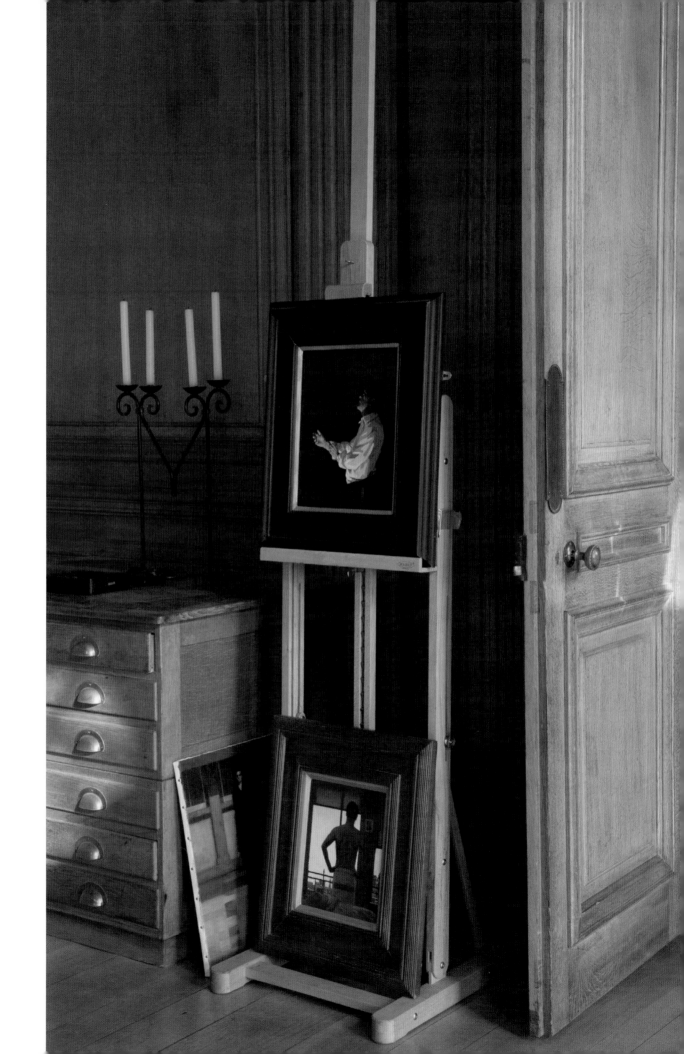

me to the wider world. Nowadays there is so much information everywhere – in magazines, on the internet – that people's worlds are so much bigger than they used to be. Back then, the only way you learned about other people was going on to university and meeting different people from different backgrounds, and I never had that opportunity. It meant that coming to London was a real eye-opener, and I started to think a lot more about my life. That's when I started listening to Dylan, to Crosby, Stills, Nash and Young. To me, they were the first people who were writing about life and not a lot of nonsense. Don't get me wrong, The Beatles were great to listen to, but their early music wasn't meaningful, not like Neil Young and Dylan. I remember listening to "Like A Rolling Stone" for the first time and it just blew my mind. That someone would describe a car as a "chrome horse" was incredible to me. In every line, there was a painting. It really struck a chord, and even now I can listen to Dylan constantly in a way I can't to anything else. Don't forget that my background was so uncultural that when I actually surrendered to this sort of music it really knocked me out.'

LUCKY 7

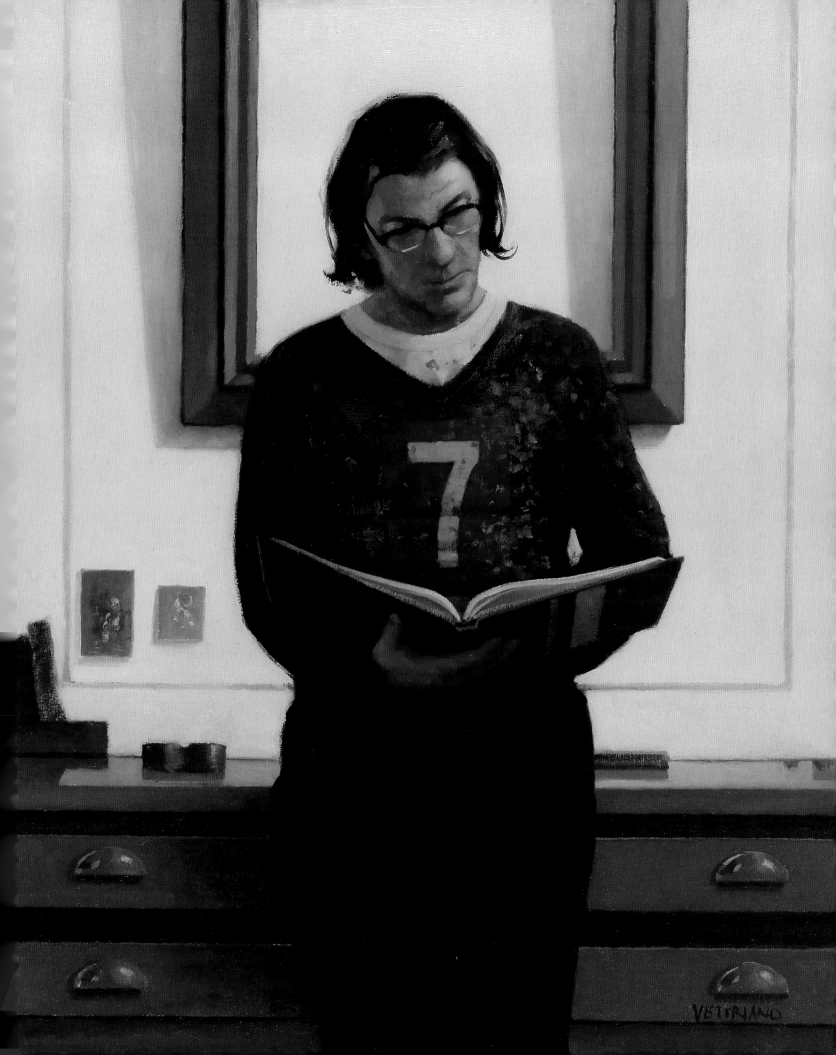

Of course, it would be almost twenty years before Vettriano would begin painting professionally. But in much the same way that imagery from the dancehalls of his youth would return to fill his canvases, so too would the music of his early manhood provide a rich vein of inspiration.

Interestingly, the same cannot be said of the world of cinema. Many observers of Vettriano's work assume he must have been influenced by the matinee stars of his childhood – the sharp-suited Americana of Cary Grant and Gregory Peck and the rugged, edgy glamour of The Rat Pack.

But in keeping with his main preoccupation of the time (women), his interests in film were strictly limited. 'If word got round that a movie had a bit of nudity in it, then off we'd go,' says Vettriano with a laugh. 'I also remember seeing the Bond films with Sean Connery, but all I was really interested in was looking like him. He had that knitted black tie, those Sea Island cotton shirts and those handmade Turkish cigarettes and we all wanted to get our hands on them, to look like him.'

Later in life, however, he would develop a deeper fascination with film. As with music, Vettriano's interest is less in the narrative whole than in individual scenes, individual frames even. And in keeping with his character, the films that strike a chord with Vettriano are those that are full of edge.

'I saw *Blue Velvet* by David Lynch in 1988 and I remember being absolutely overawed by it. I just sat there thinking that if I could recreate that sort of cinematography on the canvas, then I would be there, then I would have cracked it. Even now, remembering certain images, certain scenes, makes the hairs stand up on the back of my neck.'

Equally significant to Vettriano were the films of Martin Scorsese, *Goodfellas* and *Mean Streets*, as well as the Peter Greenaway film *The Cook, The Thief, His Wife and Her Lover*. 'It is one of the best movies I have ever seen and some of the photography in that is just amazing. I watch films to enjoy them, but I am as alert as hell to things that are going on and I'm thinking, "I would love to paint that room", or "I love the way that light is shining." I think as an artist you become hyper-aware of the effect of light and expression and you pick it up quite naturally.'

Other directors' whose work he admires include Abel Ferrara, whose film *Bad Lieutenant* stars Harvey Keitel as a drug-addict cop, and *Secretary*, directed

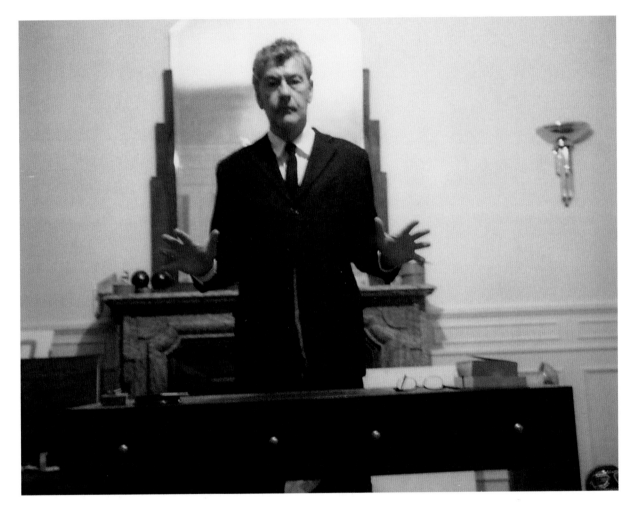

The blurred photographic starting point for *A Sinister Turn of Emotion*, a painting inspired by the Steven Shainberg film 'Secretary'.

by Steven Shainberg. The latter film provides the inspiration for one of Vettriano's latest works, *A Sinister Turn of Emotion*. 'There is a scene in the film *Secretary* where the female secretary bends down over her boss's desk and you don't actually see anything, but you know from the movement of her arms that she is actually taking her knickers down. I did a painting of my model doing that and me standing behind her.'

That Vettriano sees films in this freeze-frame way is clearly reflected in the way he visualises his own paintings. 'What happens is that I have an idea in my head and I might have it in my head for a day

or for couple of weeks and it is like an image suddenly slots in. It is like somebody operating an old-fashioned slideshow, it's like, "Here's my holiday snaps" and click, suddenly it appears. I just suddenly get this vision of how I want that painting to be, it is astonishing how it happens. Critics have often said that my work is like a scene out of a movie and, of course, that is what it is. Whereas Martin Scorsese wants to do an entire film, I just want to do a frame, one shot. And it's for the viewer to decide how they got there and the viewer to decide what's going to happen to them afterwards.'

Study for
A SINISTER TURN OF EMOTION

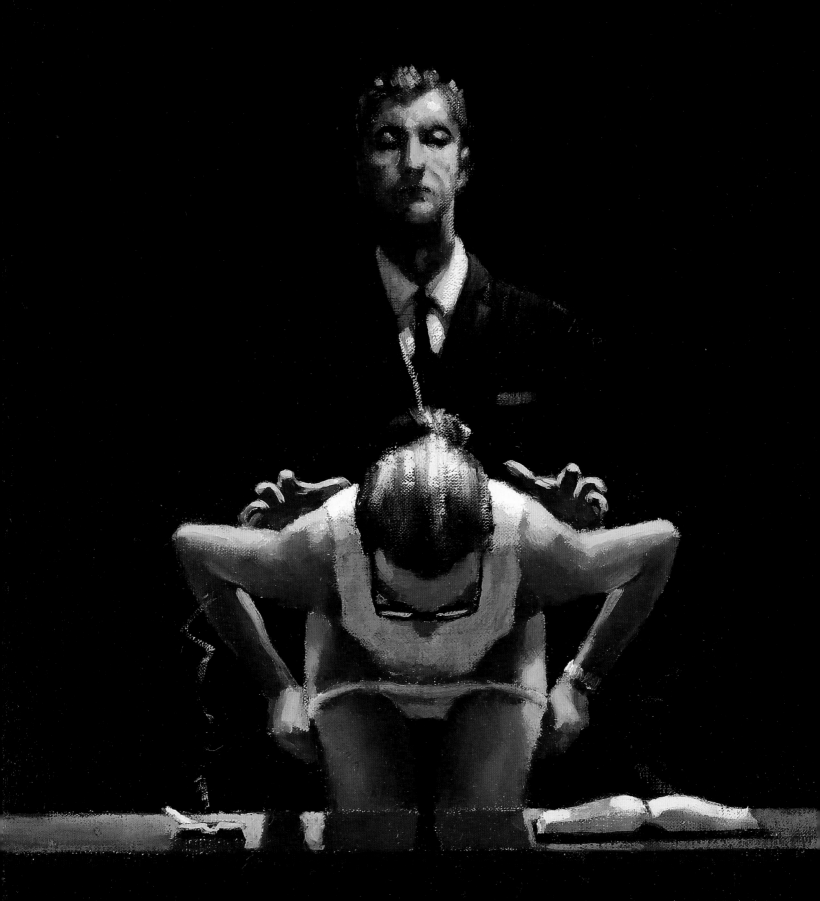

Another common misconception about Vettriano's work is that as far as artistic influences go, the American inter war realist painter Edward Hopper must have played a significant role. In fact, Vettriano was not even aware of his existence until the early 1990s, when he came across a book containing his works and was struck by obvious similarities. 'There is something about the way we both apply paint and the way we use figures that is the same, but the subject matter is very different. Hopper produced a lot of stark, lonely pictures whereas I like my people to be a wee bit closer. I am not one for painting solitude, I like something to be going on.'

Today, his favourite artist is Francis Bacon. Vettriano is fascinated by the whole package – the hedonistic lifestyle he led combined with his artistic versatility. 'I love the sheer horror of it all, and it all means so much more when you realise someone is painting from the heart and they are not just turning stuff out, that they are troubled. In Bacon's case, he wasn't a great painter but he was a great artist, and I say that because I think that while he wasn't a great applier of paint to the canvas, he had a great imagination.'

Perhaps more predictably, Vettriano also admires the work of Alberto Vargas, the Peruvian-born American artist who specialised in producing paintings of pin-up girls and erotica. While the subject matter undoubtedly appeals to his love of women, Vettriano also believes the critics have failed to appreciate the skill with which the paintings were executed.

'It has had a huge effect on every man in the big world, but people still treat it as if it is a joke, like Benny Hill,' he says. 'All right, it may be for a male audience, but you can't take it away from Vargas that he was a bloody good artist and there are artists around now who can't bloody paint and yet who are hailed by the art world.'

Of course, the subject of critical acclaim is one that is close to Vettriano's heart. For whatever the views of the art establishment, there is no doubt of the impact he, like Vargas, has had on the general public. Dubbed 'the people's painter', Vettriano has now entrenched his position in popular culture. And where he has been influenced by film and music, so now the wheel has turned full circle.

So it is that Italian *Vogue* dedicates thirty-two pages to a shoot by the celebrated American

Jack reflects on a 1950s photograph which has pride of place on the wall of his London studio.

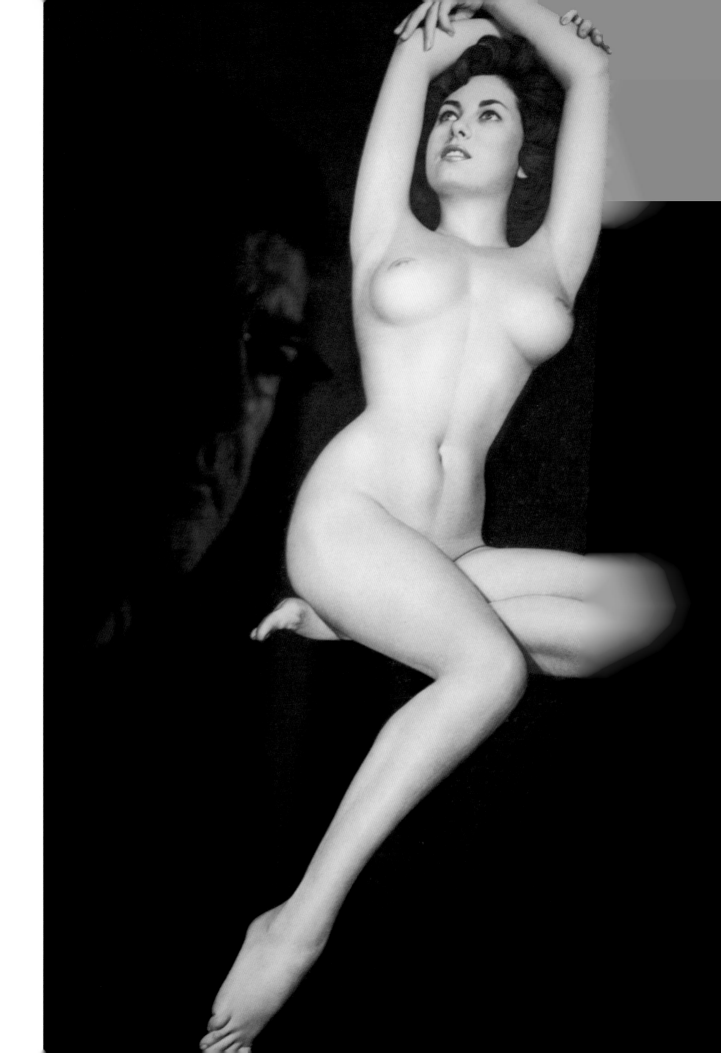

fashion photographer Steven Meisel. Entitled 'Pulp: His Kind of Woman', the stunning images are inspired by Vettriano's work – the mood, the look and the sense of narrative possibility.

So it is that the critically acclaimed indie band St Jude's Infirmary release the single 'Goodbye Jack Vettriano'. The band persuade Vettriano to make a cameo appearance in their video and he is so taken by the track that he subsequently produces a painting inspired by their lyrics.

And so it is that his paintings, the posters and prints that have sold in their millions around the world since the mid-1990s, have become shorthand for life at the turn of the twentieth century. Pick up a book – say Alexander McCall Smith's bestselling *No.1 Ladies Detective Agency* – and there's Vettriano embedded in the storyline. Tune into the radio, and there on *The Archers* his name crops up in the comings and goings of the Ambridge folk. Turn on the television, and there'll be questions on *The Weakest Link* and *Who Wants To Be A Millionaire?*, while barely a day goes by without the plethora of property programmes featuring a home whose walls aren't adorned by a Vettriano.

The band, St Judes Infirmary re-enact one of Jack's paintings in a music video.

Right Flying the flag for the band: Jack wears the T-shirt.

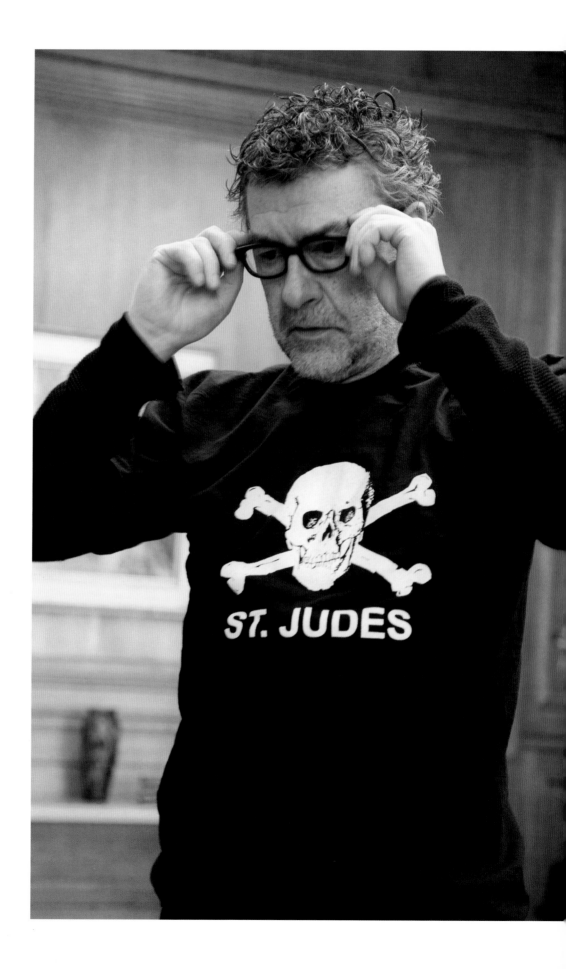

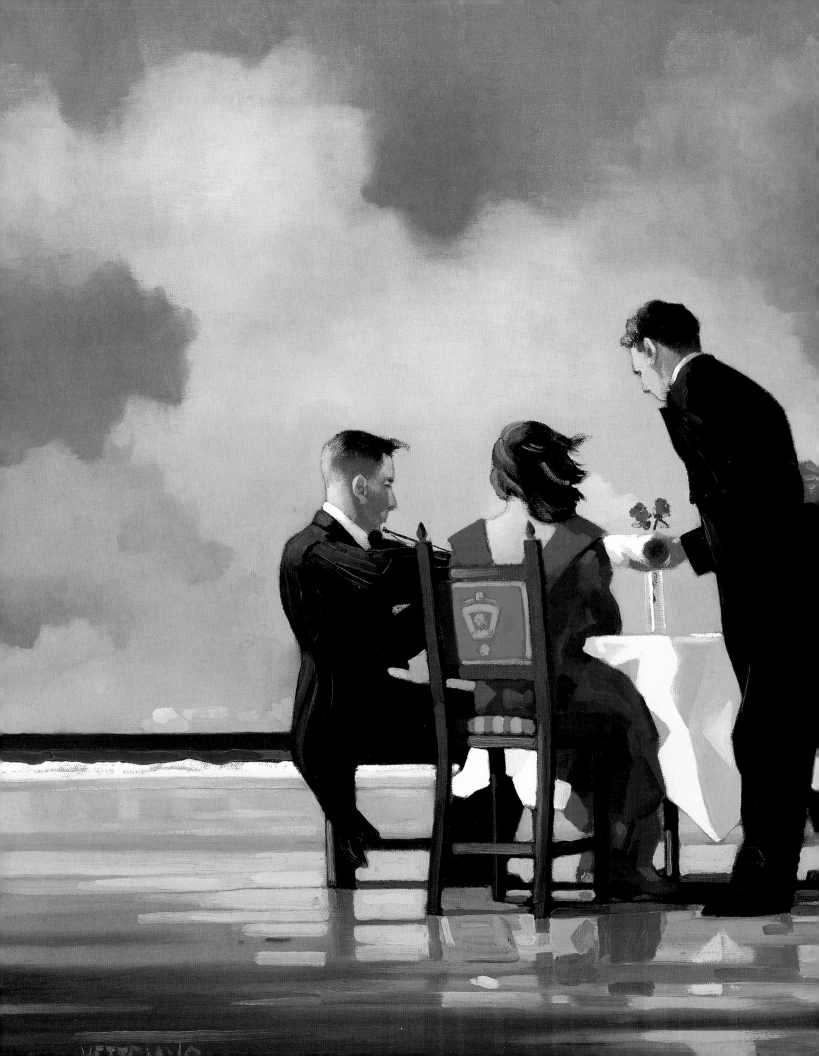

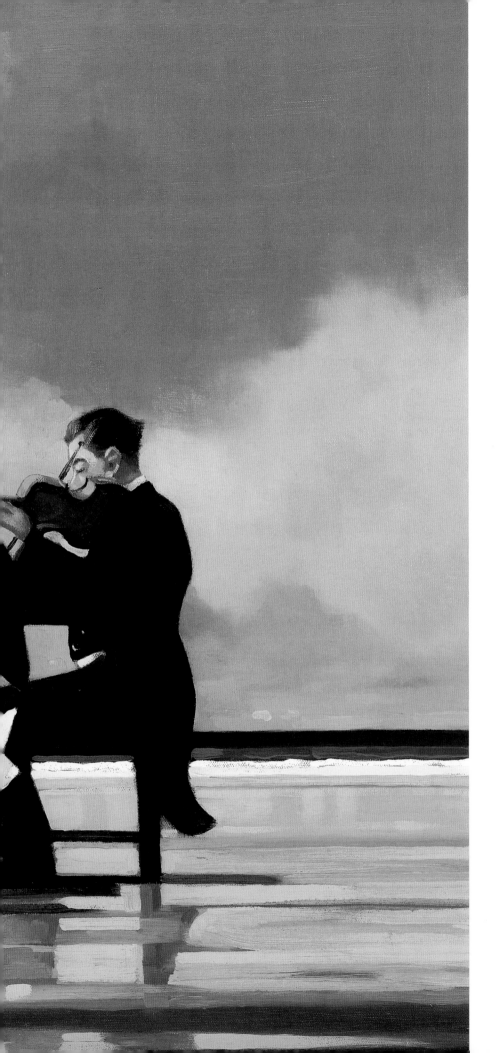

ELEGY FOR THE DEAD ADMIRAL

Steven Meisel pays tribute
to Jack Vettriano in a
photograph for *Italian Vogue*
in August 2004, inspired by
An Imperfect Past.

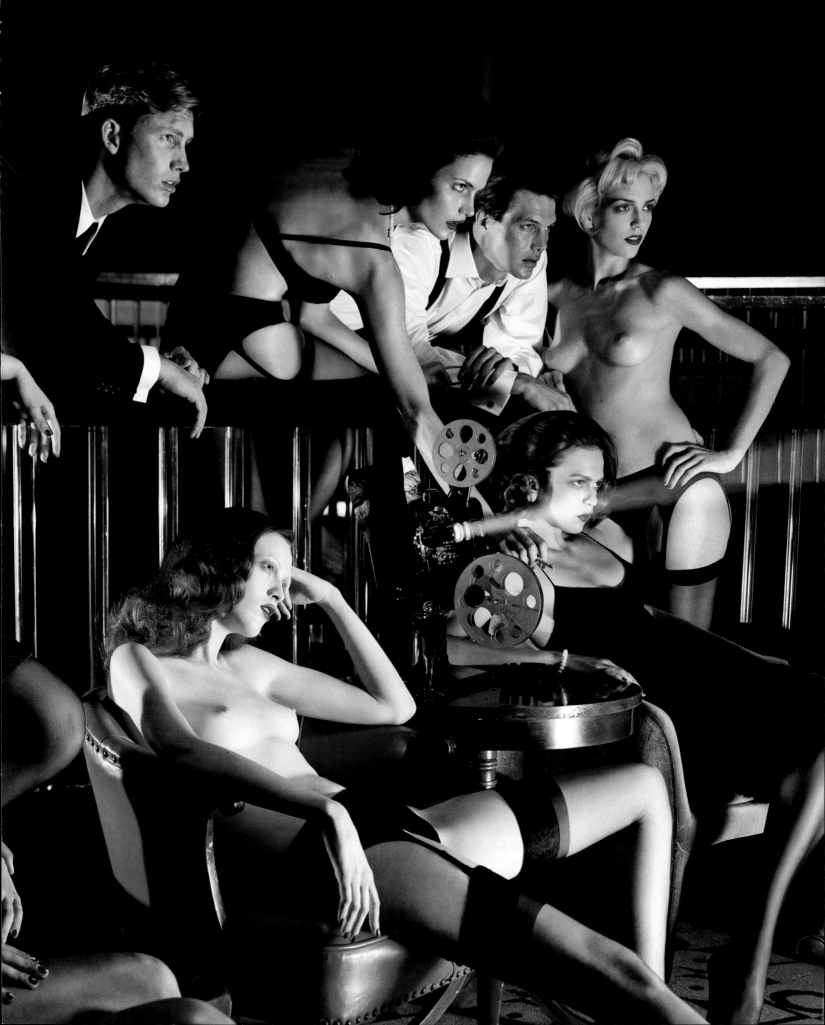

AN IMPERFECT PAST

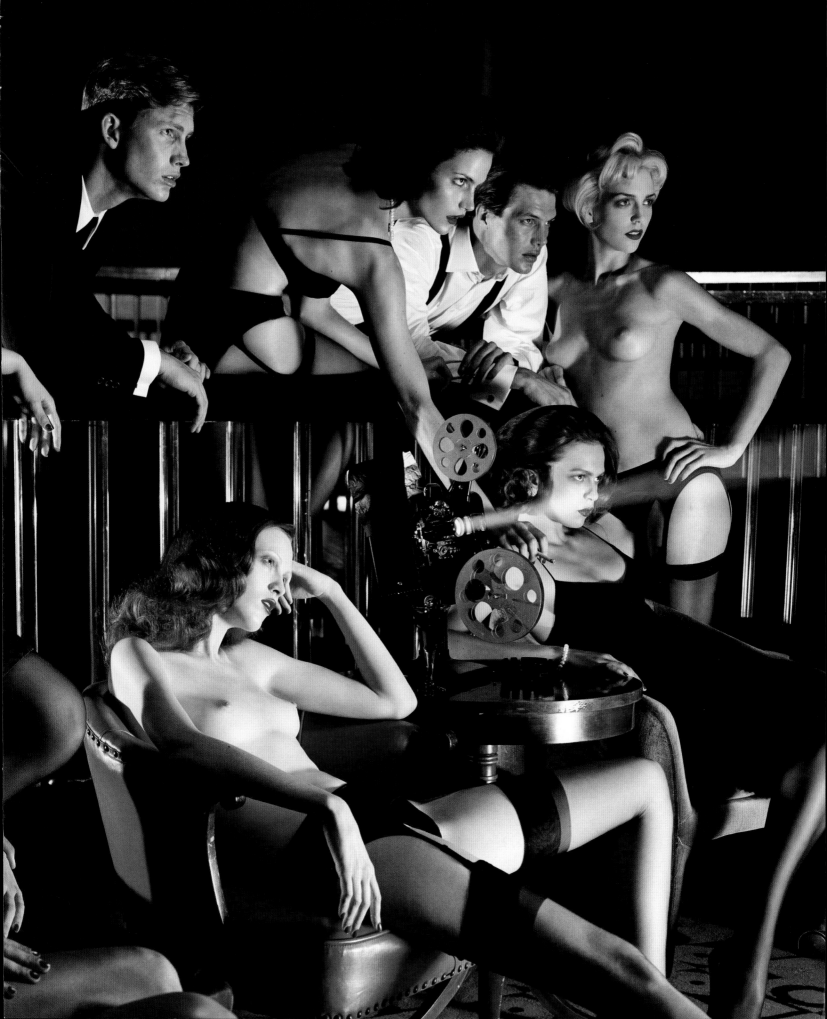

AN IMPERFECT PAST

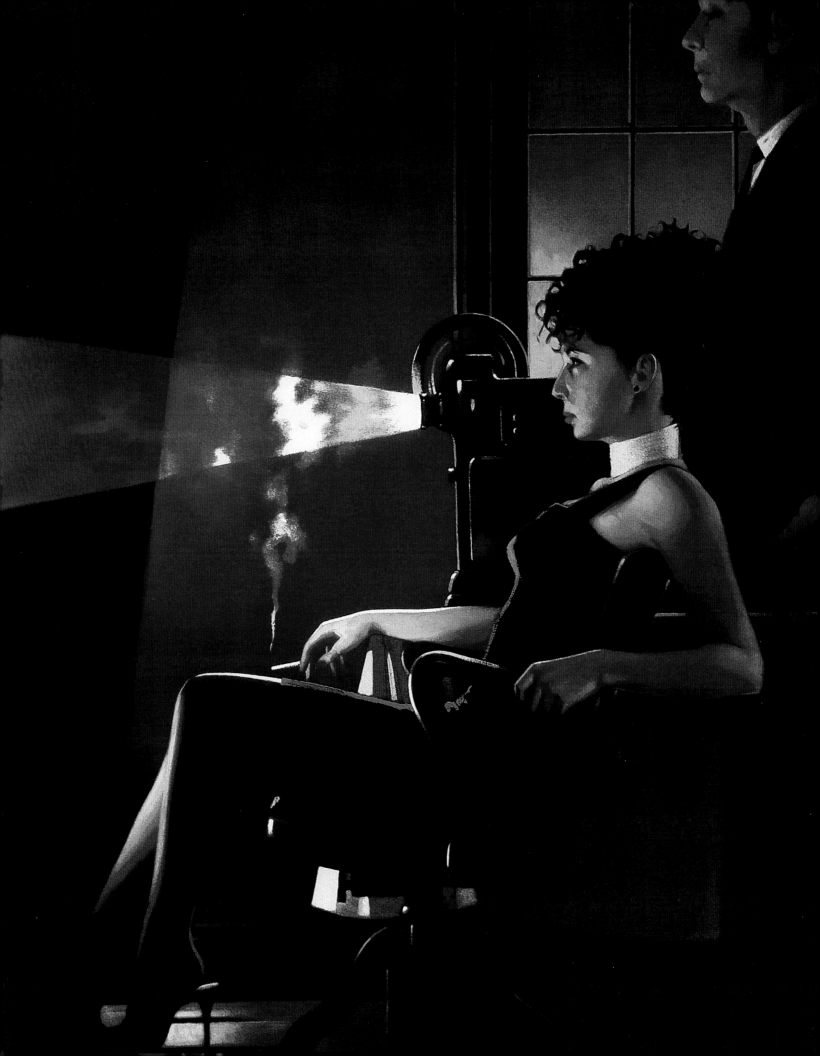

It is this popularity, of course, that has fuelled the disdain of the art world, and Vettriano is all too aware that even popular acclaim may not last forever. He draws parallels with the artist Vladimir Tretchikoff and his most famous work, *The Green Lady*, which sold millions of prints in the Sixties and Seventies. 'It was very popular and then it fell very out of fashion. If you grew up in a house with *The Green Lady* on the wall, then you grew to loathe it because you saw it every day and because it was what your parents liked. But now a new generation of people are looking at and liking it without those preconceptions. I'm sure the same thing will happen with *The Singing Butler* and my other paintings.'

In the meantime, Vettriano will get on with being Vettriano. Listening to music, painting and trying to enjoy the fruits of his success. 'I think I am both blessed and cursed. I love the opening nights and I love all the attention, but at the same time you'll never catch me at any time of the day thinking: "God, Jack, you're great." That's why I say it's a curse, because I should enjoy it more, but I don't want to let myself. Maybe it is because I subconsciously think I don't deserve it. My career is right up here and I am mentally down here. But that's just the way I am and – I suppose – that's just the way I am always going to be.'

Above Painting hanging in Sir Terence Conran's Bluebird Club restaurant in London.

Right Jack at the Bluebird Club.

'I think I am both blessed
and cursed…'
Jack Vettriano

JACK VETTRIANO
EXHIBITIONS LIST

1992	Tales of Love and Other Stories	Edinburgh Gallery	Edinburgh
1993	Fallen Angels	Catto Gallery	London
1993	Summers Remembered	Corrymella Scott Gallery	Newcastle
1994	Chimes at Midnight	Portland Gallery	London
1994	After Midnight	Everard Read Gallery	Johannesburg
1995	A Date with Fate	Edinburgh Gallery	Edinburgh
1996	The Passion and the Pain	Portland Gallery	London
1996	Halfway to Paradise	Portland Gallery at The Museum Annex	Hong Kong
1997	Small Paintings and Studies	Portland Gallery at Edinburgh Festival	Edinburgh
1998	Between Darkness and Dawn	Portland Gallery	London
1999	International 20th Century Arts Fair	Portland Gallery at The Armory	New York
2000	Lovers and Other Strangers	Portland Gallery	London
2001	International 20th Century Arts Fair	Portland Gallery at The Armory	New York
2002	Paintings 1994–2002	Portland Gallery at artLONDON 2002	London
2004	Affairs of the Heart	Portland Gallery	London
2006	Love, Devotion and Surrender	Portland Gallery	London

INDEX

Page numbers in *italic* refer to illustrations

The Archers (radio programme) 142

Bacon, Francis 140
Bad Lieutenant (film) 136
Beart, Emmanuelle 9
The Beatles 134
La Belle Noiseuse (film) 9
'Bird on the Wire' (Cohen) 128
Blue Velvet (film) 136
Bluebird Club 35, *150, 151*
Bond films 136

Cannes 102
Caravaggio, Michelangelo Merisi da 21
casinos 103, *104–5*
cinema, influence on Vettriano 136–7, 140
coal mining 83, 89
Cohen, Leonard 126, 128
Connery, Sean 136

Conran, Terence 35, *150*
The Cook, The Thief, His Wife and Her Lover
 (film) 136
Cormack, Gail 89, 95
Cote D'Azur 18, 83
Crosby, Stills, Nash and Young 134

Dali, Salvador 21, 89
'Dance Me To The End of Love' (Cohen)
 126
Darlington 89
Dufour, Bernard 9
Dylan, Bob 89, 126, 134

Edinburgh 23, 25, 95–6, 102
exhibitions 23, 95, 96, 155

Fan-Dan 84
Ferrara, Abel 136
Four Tops 132
French Riviera 20

Goodfellas (film) 136
Grant, Cary 136
The Green Lady (Tretchikoff) 150

Greenaway, Peter 136

Harrods 96
'Heartbreak Hotel' 128
Hoggan, Bill 83, *92*
Hoggan, Catherine 83
Hopper, Edward 140

Impressionists 89
Innerleven Hotel 84

Keitel, Harvey 136
Kirkcaldy 20, 23, 76, 89

Leven 20, 83, 89, 122
 Leven beach *74–5,* 76, *86–7, 87, 123*
'Like A Rolling Stone' (Dylan) 134
London 76, 89, 96, 102
Lynch, David 136
Lynedoch Place 96

McCall Smith, Alexander 142
Maggie (Vettriano's muse) 122
Mean Streets (film) 136
Meisel, Steven 142, *146–7*

Methil power station 76, 77, *92–3*, 122
Methilhill 20, 83, 122
Mitchell, Joni 126, 128
Monet, Claude 21, 31
Motown 89
music
 influence on Vettriano 126, 128, 134, 140
 lyrics 126
 see also individual groups/musicians

National Coal Board 83, 89
Nice 76, *100–1*, 102–3, *108–9*, 122
No.1 Ladies Detective Agency (book) 142

Parkinson, Michael 89
Peck, Gregory 136
Picasso, Pablo Ruiz 89
Piccoli, Michel *9*
Portland Gallery (London) *96*
Portobello beach 10
Purple Cat Club 84

Rankin, Ian *8*, 9–11, *11*
The Rat Pack 136
Resurrection Men (book) 9–10

Ross, Diana 132
Royal Scottish Academy 23, 95

St Judes' Infirmary 10, 142, *142*, *143*
St Tropez 102
Scorsese, Martin *66*, 136, 137
Secretary (film) 136–7, *137*
'Shades of Scarlet Conquering' (Mitchell)
 128
Shainberg, Steven 137, *137*
South Bank Show 10
Steamboat Tavern 84

Tamala Motown 132
The Temptations 132
Tretchikoff, Vladimir 150

Vargas, Alberto 140
Vettriano, Jack
 character 20, 126, 132
 cultural influences 126, 128, 132, 134,
 136–7, 140
 early life 21, 76, 83–4, 86–7, 89, *92–3*, 132
 early working life 18, 20, 21, 23, 89, 95
 influences on 20, 21, 83, 84, 86, *102*, 122

 later life 18
 marriage 89, 95
 models 14, 23, 25–6, 31
 opinions of 20, 150
 popularity of 140, 142, 150
 self portraits 31, *70–1*
 studios *96*, *129*, *132*
 trademarks *26*, *49*
 working methods 9, 14, *15*, 20–1 23, 31,
 34–5, 126
Vettriano Vale (Leven) 122
Vogue (Italian) 140, 142, *146–7*

The Weakest Link (TV programme) 142
Who Wants To Be A Millionaire (TV
 programme) 142

Young, Neil 134

INDEX OF PAINTINGS

Page numbers in *italic* refer to illustrations

Along Came a Spider 120–1

Blades 60–3, 65, 122

Cold Cold Hearts 9

Dance Me to the End of Love 126, 127, 128
Devotion 45

Edinburgh Afternoon 94
Elegy for the Dead Admiral 144–5
Exit Eden 116, 117, 122

Feeding Frenzy 96
La Femme au Chapeau Noir 66, 67
La Fille à la Moto 111

Heaven or Hell 9
Her Secret Life 113, 122
Home Visit 16–17, 26, 26, 27, 28–9, 36–7

The Illustrated Man 70–1, 73
An Imperfect Past 146–7, 148–9

Jealous Heart 98, 100–1

Legs Eleven 85
Long Time Gone 78, 122
Lucky 7 135

Man at Work 25
The Man in the Mirror 9
Model in a White Slip 95
Motel Love 91

On Parade 39
Original Sin 56–7

Riviera Retro 106, 122

Saturday Night 95
The Singing Butler 10, 20–1, 150
A Sinister Turn of Emotion 137, 137, 139
Soho Nights 88
Surrender 40–1

The Temptress 114

A Very Married Woman 43

PICTURE CREDITS

© Jillian Edelstein 1, 2/3, 6/7, 8, 10, 11, 12/13, 14, 15, 16/17, 19, 21, 22, 24, 26, 27, 28/29, 30, 32, 33, 35, 38, 42, 46, 47, 49, 50/51, 52, 53, 54/55, 56, 57, 58/59, 60/61, 62/63, 66, 68/69, 70, 71, 74/75, 77, 80/81, 82, 86/87, 92/93, 96, 97, 100/101, 102, 103, 104/105, 108/109, 110, 118/119, 123, 124/125, 128, 129, 130/131, 132, 133, 141, 143, 150, 151, 152/153, 160

© Jack Vettriano 25, 36/37, 39, 40, 41, 43, 45, 65, 67, 73, 78, 85, 88, 91, 94, 98, 106, 111, 113, 114, 116, 117, 120, 127, 135, 139, 144/145, 149,

© BBC Scotland 142

© Steven Meisel/Art + Commerce 146/147

ACKNOWLEDGEMENTS

Thanks to:
Ian Rankin
Tom Rawstorne
Jillian Edelstein
Steven Meisel
Maggie Millar
Nathalie Martin
Isabelle Delacroix
Scarlet Buckley
Carolyn Osborne
St Judes' Infirmary
Polly Powell
Emily Preece-Morrison
Kate Burkhalter
Jade Cresswell

The publishers would also like to extend their thanks to other contributors to the book.

Bernard Higton
Jane Deacon and Francesco at The Bluebird Club

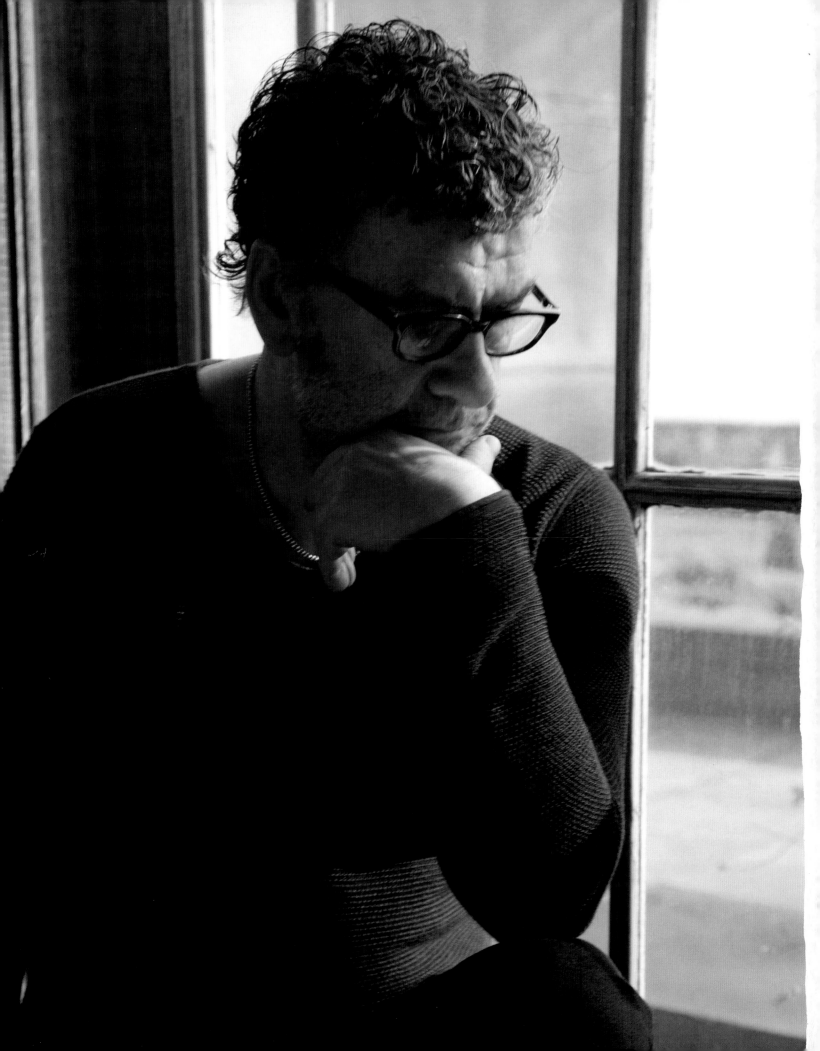